DATE DUE	
FEB 2 3 1999	
APR 1 9 1999	
NOV 1 1 2000	
NOV 1 7 2002	
AUG 2 4 2004	
MAR 3 2013	

GAYLORD — PRINTED IN U.S.A.

THE ART OF
THE BROTHERS HILDEBRANDT

THE ART OF THE BROTHERS HILDEBRANDT

IAN SUMMERS

BALLANTINE BOOKS • NEW YORK

IN LOVING MEMORY OF OUR FATHER, GEORGE J. HILDEBRANDT

THE ART OF
THE BROTHERS HILDEBRANDT

After a series of left and right turns down narrow New Jersey lanes, you pull up to an old Charles Addams-style gray Victorian house. You travel along a still narrower mud and cobblestone driveway, past the house to an old gray barn. You look to the right and recognize the ancient oak tree from an illustration in the Tolkien calendar. That barn in the meadow behind the house is the studio of the Brothers Hildebrandt, and what a wonderment that studio is.

You climb a rickety staircase to the second floor. There's a large picture window covered with a matted worn pink woolen blanket that functions as a curtain to control the light. The studio is strewn with papers. It appears that the butt of every cigarette they've ever smoked is stomped on the brown wooden floor. On a table sits a clay model of Shelob the Great, Tolkien's monstrous spider. Costumes hang from a rack in the rear: cowls, capes, boots, togas, helmets, bows, arrows, daggers, swords, and various unidentified clothing fragments. Photography stands and lights are stacked up precariously. Drawings are taped to the walls. Rejected pencil sketches on tissue paper are rolled into little balls, joining the cigarettes and paint stains on the floor. There is a wobbly ladder stretching up to a loft above part of the studio which functions as a theater balcony for children and friends who often gather around to watch the Brothers create.

But it is color that makes the most overwhelming impression, triggering a myriad of emotions. Pinned to one wall are some thousand Magic-Marker-colored storyboard frames that serve as an outline for the Brothers' own novel, *Urshurak*. Paintings stored in stacks are both familiar and strange. On a custom-designed easel in the center of the studio is a large painting in progress. The worktable is cluttered with tubes of acrylic paint and pieces of aluminum foil with titillating patches of color.

The telephone rings but cannot be found. You follow the sounds and rediscover that connection to reality buried under piles of paper and fabric. The phone is covered with drippings of paint: red and blue and black and green and purple and...It's amazing that it functions at all. You later learn that the telephone was a victim of a bayonet attack from an enraged Greg. There are terrible slash marks in the receiver. For days, and even sometimes for weeks, that telephone is the only interruption in the Brothers' fantasy world. Since the publication of the Tolkien calendars and the *Star Wars* posters there are more interruptions than ever before by curious fans. The telephone number is now a strictly guarded secret.

In another corner in a cardboard box on the floor is a pile of well-read but unanswered letters—letters inviting Tim and Greg to speak at fan conventions, letters praising and criticizing their depictions of Tolkien's characters, letters from art collectors begging to purchase a favorite painting. The Brothers fully intend to answer each and every letter, but then the muse strikes and they are propelled back into their creative fantasy world. It wasn't always like this. Life for the Hildebrandts and their families was once much simpler and less demanding—but also less rewarding.

Greg and Tim Hildebrandt were still relatively unknown illustrators in the fall of 1974. The Brothers had spent a decade or so illustrating children's books and creating art for an occasional advertisement. They were frequently asked to work in the style of other popular illustrators, and they were very good at these imitations. The Brothers hated what they were doing, but it was a living. They were extremely frustrated in their careers and searched for ways to get their own work recognized and accepted.

During the late 1960s the Brothers discovered the works of J. R. R. Tolkien. They read the books themselves and read them again to each other and their families. The material was so exciting visually that they dreamed of one day illustrating Tolkien's complete works. They wrote notes in the margins, underlined passages, and sketched the characters on scraps of paper.

In the fall of 1974, Rita Hildebrandt, Tim's wife, came upon a copy of the 1975 Tolkien calendar with illustrations by Tim Kirk in her local bookstore. It was this calendar that would change their lives.

Ian and Betty Ballantine, who have played such an important role in the popularization of science fiction and fantasy literature in recent years, published the first authorized paperback edition of J. R. R. Tolkien's *The Lord of the Rings* in 1965. Subsequently Tolkien fans enjoyed the first *Lord of the Rings* calendars, for the years 1973 and 1974, which used Tolkien's own illustrations with maps by Pauline Baynes. For the 1975 calendar Betty Ballantine discovered Tim Kirk's work in Kansas City, and she purchased the paintings outright.

But, what about next year? The Ballantines hedged their bets by running a paragraph on the back cover of the calendar:

We hope to find other artists who are inspired to do their own conceptions of *Middle-earth* so that we shall be able to offer calendars for future years.

Artists were requested to send portfolios to Ballantine's art director; I had held that job for about four months when the responses and portfolios started rolling in. There were several hundred inquiries, most of them from well-intentioned amateurs, and responding to each took a great deal of time. Ian and Betty Ballantine were in the process of leaving the company to start Peacock Press. We all knew that the selection of a new illustrator for the next Tolkien calendar was of critical importance. The sales potential of the calendar meant big business, and I was looking for the best. There were many professional artists who could paint adequate illustrations, but this had to be a project of love. The illustrators for this next calendar would have to be *obsessed*.

It was February 1975, and we had yet to make a decision. I'd narrowed down the field to three illustrators: all professional, all talented—none obsessed. The magic was still missing. Calendars are delivered to the booksellers in August of the preceding year to give them the longest possible on-sale period. Allowing two months for printing and a month for preparation and design left only four months for an artist to produce fourteen major paintings. We needed all the help we could get.

February 7, 1975 was one of the coldest, ugliest days of the year, with sleet and howling wind. I reviewed another dozen portfolios that morning, and was about to leave for a luncheon meeting when Ballantine's receptionist buzzed me on the interoffice phone. "Ian," she said, "there's a couple of people out here to see you." Although I reminded her that I don't see people without appointments, she was persistent. "Ian, honey, I think you really ought to see this."

I took a deep breath and walked out to the reception area. Before my eyes were a pair of identical twins dressed in woolen plaid shirts—bearded, skinny, wet, and shivering. Greg's pants were so covered with paint they looked as if they would stand up by themselves. There was snow melting in his ponytailed hair. Tim was much neater. He was bearded, too, but neatly trimmed. I wouldn't learn until much later that it was these differences, the *Odd Couple* syndrome, that clearly defined the separate personalities of the men. Each of the Brothers carried a large black plastic garbage bag. I introduced myself and asked if I could help them. Greg said something like, "Pictures, man, we make 'em—Tolkien pictures." I suggested that they make an appointment with me to show their work and bring their portfolios with them. Tim explained that their portfolios were indeed with them, and they proceeded to empty the contents of the black plastic garbage bags on the floor of the reception area. There were probably some fifty black-and-white drawings on crumpled, coffee-stained, dog-eared, torn sheets of tissue paper. The twins were on their knees on the floor smoothing out their presentation. My eyes popped, and a chill traveled up my spine signifying what has been called the "eureka response." In fact, I even said "Eureka!"

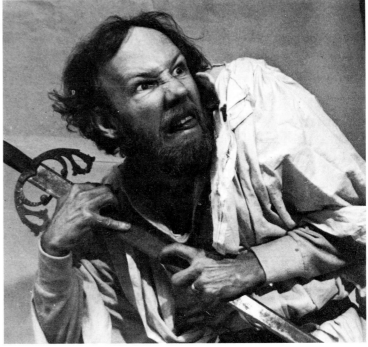

The Brothers had taken Ian and Betty Ballantine's call for artists to heart. There were enough preliminary drawings in their peculiar portfolios to fill several Tolkien calendars. Each one was beautifully thought out. But, could they paint? They assured me that their paintings were every bit as good as their sketches. I commissioned them on the spot to create a painting for J. R. R. Tolkien's juvenile stories, *Smith of Wooten Major and Farmer Giles of Ham.*

I wanted everyone at Ballantine to see the work, but unfortunately it was lunchtime and editors are then traditionally

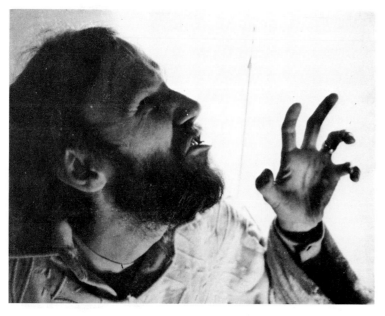

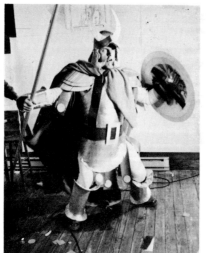

carrying on business with authors and agents at sophisticated restaurants. We arranged for Greg and Tim to bring in their paintings the following week, at which time they would also have their solutions for the newly commissioned cover. About thirty paintings arrived for the meeting, and every space in the conference room was filled with Hildebrandt art. The staff was invited in small groups to see the work, and a party materialized spontaneously. The editors called the marketing department, who called the advertising department, who called the publicists. Judy-Lynn del Rey, Ballantine's science fiction editor, called her husband, Lester del Rey, who would later act as a technical consultant to the project. I called Ron Busch, Ballantine's president, and had the liquor store deliver champagne. Everyone in that conference room knew this was a major publishing event.

———————⟫⟨———————

I t all began in Detroit about thirty-nine years ago. Not surprisingly, the birth of the identical twins caused quite a stir in the Hildebrandt household. Greg is approximately five minutes older than Tim, and it was weeks before their parents, George and Germaine, were able to tell them apart. Even their earliest childhood needs, desires, and interests were identical. Perhaps it is not so surprising that they have done just about everything since then together.

As far back as the twins can remember, they were fascinated by science fiction, comic books, and the movies. They spent hours in their room copying characters from their favorite strips and often creating their own stories, with their parents' encouragement. Later they created their own 8mm motion picture in the family garage with such elaborate special effects that they nearly destroyed the building. Their parents were still encouraging. Tim and Greg never wanted for supplies. "Pa" would bring home samples of paper, fabrics, tapes, pencils, etc. from General Motors' supply room. Their elaborate Green Hornet and Green Lantern costumes were created with chalks and crayons on a dust cloth that was formerly used to cover automobile design models. Sheets and pillowcases were discreetly borrowed from their mother's linen closet and transformed into more use-

ful objects such as gorilla costumes and puppets. Their marionettes, hand puppets, and ventriloquist dolls were imitations of the works of Edgar Bergen, Bill and Cora Baird, and Murray Bunin. Bunin's Pinhead and Foudini remain their favorites, but it was Kukla and Ollie that got the Brothers into the most trouble. Ollie's hair was constructed of fur borrowed from what they thought was an inconspicuous place on their mother's new fur coat. Ollie's red velvet lips were a clipping from the lining. There were long faces in the Hildebrandt household when the discovery was made two weeks later, but somehow George and Germaine Hildebrandt continued to be encouraging.

Saturdays were spent at the local movie houses, where the twins would sit for performance after performance of their favorite films. They've lost count of the number of times they saw *Fantasia, Snow White,* and *Pinocchio.* The Brothers dreamed of a career with the Disney studios. Then there were the great and not so great science fiction movies of the 1950s, which were to play further upon their imaginations. Edgar G. Ulmer's *The Man from Planet X, 20,000 Leagues under the Sea,* and Howard Hawks's *The Thing,* as well as *Killers from Space, Monster from the Ocean Floor,* and *Invasion of the Body Snatchers* lured the Hildebrandts to the movie theater. The Brothers were true fans. Even today they could tell you the names of each and every special effects person, cameraman, director, and studio for just about any science fiction film of the fifties and sixties. On the bus ride home from the movie house they would discuss all the ways they would have made the movie better. They'd lie in their beds talking softly—and often not so softly—about what they had seen. The next day they'd get back on the bus and go see it again. There was one film that they couldn't find a way to improve: *The War of the Worlds.* George Pal was and is Tim and Greg's filmmaker hero. Although the Brothers have never met Pal, even today they discuss calling him on the phone. Maybe someday they will.

Greg and Tim's reading habits were somewhat predictable: H. G. Wells, Jules Verne, *Frankenstein, Dr. Jekyll and Mr. Hyde,* all the classic adventure and science fiction stories. They read all the Edgar Rice Burroughs they could get their hands on—all twenty-four Tarzan novels and *John Carter*

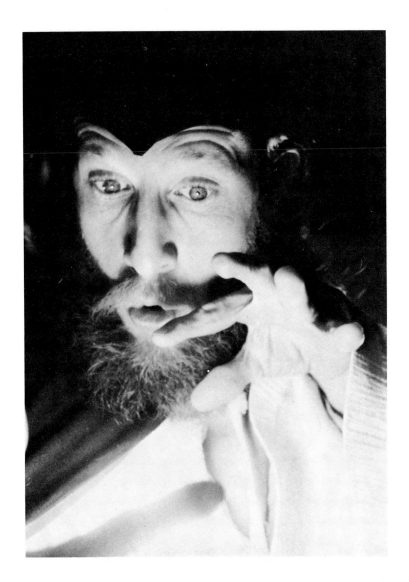

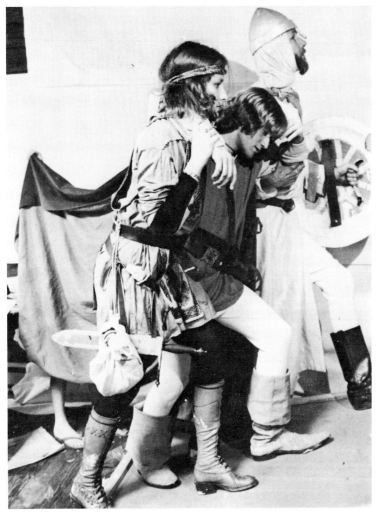

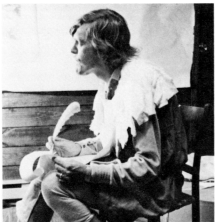

of Mars. But out of all the great Burroughs tales, the *Pellucidar* novels challenged their imaginations the most. The Brothers had an intuitive appreciation for greatness. While they were reading the adventures, they also read and admired *The Adventures of Raggedy Ann and Andy* by Johnny Gruelle, one of the finest children's fantasy series.

The twins would draw and redraw *Superman, Plasticman, The Blackhawks, The Green Lantern, The Green Hornet,* and *Terry and the Pirates.* Just a few months ago they received a fan letter from Milton Caniff which is one of their most treasured possessions. When it wasn't the comics, they'd spend hours studying the powerful narrative illustrations of Howard Pyle, N. C. Wyeth, and Maxfield Parrish.

The Brothers were "beatniks" during their high school years, wearing black turtlenecks, black trousers, "shades," and sandals. They were often accused of being antisocial. While the other kids were experimenting with dating, the twins retired to their room to experiment with animation, drawing, and model building. They'd work for hours on the scripts and storyboards for their own 8mm film. The only disagreements the Brothers ever had were concerned with one of them not working hard enough. If Gregory wasn't sketching he would suffer the wrath of Timothy and vice versa. High school was considered by Tim and Greg to be an interruption in their filmmaking. They were average students, but managed to achieve straight A's in biology and astronomy. While the other kids were at the high school prom, Greg and Tim were hanging out at the Motown coffeehouses—sipping espresso, snapping their fingers, sketching, and listening to poetry and jazz. The Brothers spent their graduation day in June of 1957 at the movies watching *Attack of the Giant Mantis.* They looked so young that they even had to show their ID cards to gain admission.

Ron Griesbeck, an early childhood friend of the Brothers', was the only authentic genius they were to meet in their lives. Ron played a major role in steering the Brothers toward a career in filmmaking and illustration. He could play a symphony by ear on a variety of instruments. He had an insatiable curiosity about flying saucers, science fiction, and biology. He mesmerized the twins one afternoon by removing the heart of a rat and keeping it beating for five

minutes. Ron's greatest influence was in the field of animation. Ron built models and animated his own segments of *The War of the Worlds.* When the twins got their first Brownie 8mm movie camera in 1954, Ron taught them how to use it.

The twins joined the peacetime Army just months after graduating from Avondale High School. The six-month Army Reserve program took them to Fort Leonard Wood, Missouri, for two months and to Fort Riley, Kansas, for four months. The service was relatively uneventful until Tim was almost court-martialed. Greg and Tim both worked at first as clerk-typists, but one morning Tim was transferred from the laundry to the motor pool, where he was told to drive a two-and-a-half-ton truck. Although Tim didn't know how to drive a car, let alone a truck, in typical military fashion he was told he had ten minutes to learn. The sergeant was going to make a mechanic out of him, and his first job was to drain the transmission fluid from his vehicle and replace it. Tim begged a friend to show him which end of the motor contained the mysterious fluid. Then, feeling proud of his accomplishment, Tim dragged what he thought were 20-gallon drums of new transmission fluid from a nearby shack to his vehicle and finished the job. At the next morning's drill both Hildebrandt twins were ordered front and center. (Even the Army had a difficult time seeing them as separate people.) Tim and Greg were informed that the Army was about to start court-martial proceedings against them for their costly prank. Days later Tim learned that he had unwittingly replaced the transmission fluid with olive-drab paint. The rest of their service time was spent cleaning latrines and doing KP.

While in the service the twins discovered their inherent psychic, or extrasensory powers. Tim and Greg were subjects of tests for ESP using decks of cards and concentration experiments. Predictably, they were right most of the time. The Brothers duplicated this feat for me one evening in my home just a few years ago. After we had killed a bottle of Scotch whisky, Greg retired to my den while Tim remained in my living room. I shuffled the cards thoroughly. Tim concentrated on the cards as I turned over the entire deck one by one. Greg guessed about seventy percent right from the other room.

Tim and Greg have also experienced the strange phenomenon of dreaming identical dreams simultaneously. Today, although the Brothers live thirty miles apart, if one of them suffers a restless or sleepless night, he expects a call from the other to see what is wrong. One brother will start a sentence and the other will finish it. This behavior isn't considered strange by Tim and Greg. They've been doing it all their lives.

The twins attended the Meinzinger School of Art in Detroit immediately after leaving the Army. Their formal art training lasted less than a year. It wasn't that the school had nothing to offer; it was just that they were far ahead of the rest of their classmates. The Brothers had learned the fundamentals by trial and error years earlier. This brief period was the extent of their formal education. The academic experience was enough to give them the positive feedback, discipline, and encouragement they needed. They would both pursue their lifelong dream of careers in animation.

It never occurred to Tim and Greg that they could have or even desire separate careers. After several odd jobs, they landed "twin" jobs at the Jam Handy Company of Detroit. The Brothers were put to work in the animation department, where their first assignment was to opaque acetates for an Air Force training film. They worked as hard learning the various animation techniques as they did putting that 8mm homemade film together. By the mid-sixties, Greg and Tim were designing films, creating storyboards and finished artwork, and mastering set design and stop motion and live-action animation.

While working at the Jam Handy Company, the twins met Jean LeRoy, a former Ringling Brothers clown, who has a real-life big red bulbous nose and a crop of fine red hair that would be the envy of any circus performer. His house in Detroit was constructed with old panels from real circus wagons. His basement was one of the Hildebrandts' favorite retreats. LeRoy's workshop was the place where most of Jam Handy's miniature sets were built. Tim and Greg attribute their knowledge of set design and stop-motion animation to LeRoy, who was also a vital motivational spirit in their careers. LeRoy invited the twins to move to New York with him to help design and construct the Disney Pavilion for the 1964 World's Fair. The Brothers were torn between

LeRoy's offer and an opportunity to undertake a film project for the Catholic Church. They opted for the latter job and moved east to work with Bishop Fulton Sheen of New York, for whom they would make several motion pictures. (After the Fair, Jean LeRoy moved to Arizona, where he has constructed one of the world's most elaborate and amusing tourist attractions: a one-acre hand-carved miniature circus.)

In 1963 Greg married Diana Stankowski, and the honeymoon couple rented their first apartment in Jersey City, New Jersey. Tim moved in across the street. Then, in 1965, Tim met Rita Murray at choir practice and courted her for four months before they were married. Rita, who was from San Antonio, Texas, was in New York studying at the Fashion Institute of Technology on a *Glamour* magazine scholarship. Tim and Rita eventually moved to an old Victorian house in northern New Jersey not far from Greg and Diana, who live on the property where the studio-barn stands.

In 1969 the Church sent the Brothers to Africa to film a documentary on the Church's missionary work. Tim and Greg spent several months filming what they saw, and when they made their final presentation to Church officials, they were promptly relieved of their responsibilities. The Brothers did not create the propaganda film the Church expected; instead, they showed Africa the way they saw it, with all the poverty and political unrest.

The Vietnam War was looming, and the Brothers became active in the antiwar movement. Their attentions and creative energies were diverted from the drawing boards to the political arena, where they worked with the Berrigans and others by helping to produce the political posters of the era. But now both Hildebrandts had families, and families need to eat. Tim and Greg knew that they could somehow make it as illustrators. They began showing their portfolios to art directors of various children's book publishers. Someone at Western Publishing Company recommended them to Holt, Rinehart & Winston, where they received their first assignment. Many imitative illustrations for children's books

followed, with an occasional commission for advertising art.

The frustration of not achieving recognition brought Greg to a psychotherapist who was starting a therapy group just for artists. Tim joined the group later. Therapy gave Greg the strength to try some painting on his own. This was the first and only time that the Brothers would work separately. Greg's works are visual renderings of his dreams. They are surrealistic symbolic paintings, some of which are reproduced here. Since Greg was working alone, Tim was then compelled to try some painting on his own, too. Tim produced fantastic images of castles, dwarfs, centaurs, and other fanciful and imaginary figures. Their styles differed for the first and only time. Greg painted in acrylic, and Tim's images were painted in watercolor washes. However, the groundwork for the fabulous Tolkien paintings was being laid. While the subject matter in their personal paintings varied, both artists created pictures that were narrative in nature. The twins' objective is not to paint for painting's sake, but rather to tell stories. Painting is but one medium with which to achieve this aim.

There have been many stories about the Brothers' working habits, and most of them are surprisingly true. The Brothers often work simultaneously on the same painting. Tim will start on one side and Greg on the other, and they meet somewhere in the middle. This approach is used only on large works such as the centerspreads for the 1976 and 1978 Tolkien calendars. The famous *Star Wars* poster is an example of another unusual feat. Since the twins' painting techniques and styles are totally interchangeable, they were able to complete the poster in just three days by alternating on a round-the-clock basis. Since there are two of them, Tim and Greg are able to work twenty-four hours a day and still get sufficient sleep. Greg may start the piece and work until he is tired. Tim picks up where Greg leaves off and proceeds until he's tired. Back and forth they go until the finished painting materializes.

When I first heard of this approach, I thought they were kidding. It is impossible for two artists to work on the same

piece without displaying a distinct difference in brush strokes. I examined the work under magnification to discover that the phenomenon is absolutely true—the brush strokes are virtually identical. While this approach to image making is not the Brothers' preferred method of working, it demonstrates a unique capability and indeed helps them meet some rather tight deadlines.

The Hildebrandts have developed their approach to solving illustration problems over a period of years and through trial and error. Many illustrators consider the ideation process the most difficult and very lonely. The Brothers have the advantage of being able to bounce ideas off of each other at every stage of development. Either Tim or Greg will read a manuscript from beginning to end, underlining and making visual notes as he goes. In the discussion that follows, any disagreement is ironed out right then and there. Very rough Magic Marker layouts are developed for composition. Tighter characterizations are created in pencil. Black-and-white comprehensive drawings follow in graphite on tissue paper. These drawings are the first artworks that the client sees. They are so comprehensive and beautiful that art directors have often suggested using the drawings rather than the paintings.

With approval from a publishing or advertising-agency art director, the Brothers return to their studio to commence painting. Masonite panels are cut to size, and a minimum of two coats of gesso are brushed on the surface. Colors are planned and their palette is set. Tim and Greg work exclusively with acrylic paints, which have some very difficult properties that must be mastered. Since acrylics dry almost instantly when applied, the twins had to develop a system of control to enable them to wet-blend colors directly on the ground. Large batches of colors are mixed on pieces of aluminum foil, and these are sprayed frequently with water. This keeps the color batches workable for long periods of time. Tim and Greg will mix a complete range of values before starting to paint, which saves time and matching problems later. There may be as many as ten globs of paint mixed to achieve all the flesh tones of an alien or humanoid. All the lighting and shadow problems are worked out in advance. The Brothers used sable brushes for most of their work created over the last five years.

Earlier paintings were mostly in watercolors, and a completely different approach was required then. The drawing is transferred to the Masonite by darkening the reverse side of the sketch with graphite and tracing over the line work. Broad washes are laid in, usually in monochromatic hues. The Brothers use a direct painting technique with little or no underpainting, and there are no glazes. Each figure is modeled in paint, and the Brothers frequently refer to Polaroid photographs of models in costume taken prior to their actually tackling the finished art. These photographs are taken for reference only and serve to give the artists general information required to create the mysterious lighting effects they are famous for.

The photo sessions develop into spontaneous parties after a few hours of hard work. All of the Hildebrandt models are personal friends and include their lawyer, schoolteachers, a cabinetmaker, neighbors, and children. Rita Hildebrandt sews the more elaborate gowns, and much is improvised on the spot. Helmets and shields are made of aluminum foil and wire hangers. Monsters are made of clay, and elaborate masks are made of papier-mâché. The twins try to photograph three setups a day. There is always an ample amount of wine and beer, and toward evening the clowning begins. Everyone dons a costume, more wine, beer, and cheese are brought out, baroque music is played, and the fun lasts late into the evening.

Letters from fans frequently inquire about why characters and places look the way they do. The Brothers point out that they are "illustrators," and the images they create, with few exceptions, are true to the descriptions in the book. They feel that they must make fantasy real and not cartoonlike. They made the Hobbits look like English working-class people, because that is what Tolkien intended. The biggest liberties they took were in their portrayal of Gandalf, who was described by Tolkien as having long eyebrows that extended beyond the rim of his hat. Greg and Tim eliminated Gandalf's silver scarf because they just didn't feel it worked.

Since the twins are constantly growing in their work and evolving their technique and style, each series of paintings appears to be quite different and fresh. The three Tolkien calendars are substantially different when examined side by

side. The 1976 calendar is much less painterly than the 1978 calendar. Yet there is a continuity in characterizations and style evident throughout. Their most recent paintings are more spontaneous looking because the Brothers are using paint right out of the tubes. They use raw colors in the foreground and create the feeling of distance by adding white to the pigment. They never use black. Purples are used to create the rich, deep shadow areas.

Tim and Greg have been known to celebrate the production of their finished work with great fanfare. The day that the 1976 calendar was delivered to Ballantine Books from the printer was a day that won't be forgotten for a long time. We all adjourned to a sidewalk café for a glass of wine to celebrate the event. The Brothers, armed with a couple dozen calendars each, began to pass them out in the street. People couldn't believe their eyes—or their ears, for the Brothers were chanting excerpts from Handel's *Messiah* and "yea, verily, yea."

Several days later a fabulous press party was held at the New York Society of Illustrators. Invitations were delivered by costumed strolling minstrels. The response was so overwhelming that we had to turn away over a hundred people at the door. A cake was made up with icing that reproduced the centerspread painting. Tim and Greg arrived in costume: turn-of-the-century evening dress with top hats and tails. This was a spectacular opening for a spectacular career. In a very short time the Brothers Hildebrandt had countless fans around the world.

After three years and over forty-five major paintings, Tim and Greg felt that they had exhausted the Tolkien material. It was time to give someone else a chance, and they felt that the fans were entitled to other images and visions. The Hildebrandts reluctantly turned down the commission for a 1979 calendar. But what would they do next?

In the late summer of 1977, Greg, Tim, and I sat down to a celebration lunch at the Society of Illustrators, where they had recently won the coveted Gold Medal for the best book illustration of the year for their cover for *Clive,* based on a Renaissance portrait of a prince by Tintoretto. There was some discussion about conjuring fantasy images for their own calendar. I asked them if the images they had in mind had any continuity. Tim said that they could be conjured that way. If the images had continuity, then they must tell some kind of a story. If they told a story, why not write a book! Tim and Greg scratched their twin heads and said that they are not writers. I reminded them that they were great storytellers and suggested that they draw a novel. Two months later Tim and Greg had completed over one thousand Magic Marker drawings that told a remarkable story. They had created a mystical continent called Urshurak. There were witches, goblins, amazons, elves, and even a pair of twin dwarfs! Each frame of the storyboard was a complete painting in itself. The response from paperback houses was enthusiastic, and Bantam Books was top bidder for publishing rights. The novel, with sixteen full-color paintings and fifty black-and-white drawings, will appear in 1979.

———————— ✄ ————————

Tim and Greg Hildebrandt are probably the most unusual artists working in the illustration field today. Their meteoric rise to superstardom has been incredible: Fans tug on their shirts at science fiction conventions, art directors beg to work with them, their fees have more than tripled, and the Hildebrandts are in a position to be very selective in the commissions they accept. The Brothers' work has been exhibited in major shows in New York and San Francisco; a major retrospective will be mounted in Tokyo early in 1979. Somehow, throughout all of this, the Brothers Hildebrandt have maintained a sense of naiveté and humility. They will spend hours talking to fans and students—anyone who is knowledgeable about science fiction films. My association with Tim and Greg has been gratifying, and I consider them to be among my dearest friends. This book is a testimony to the pleasures they have given to fans all over the world, and a tribute to two of the most dedicated illustrators in America today. The art speaks for itself. Feast. Enjoy. And wonder.

THE ART OF
THE BROTHERS HILDEBRANDT

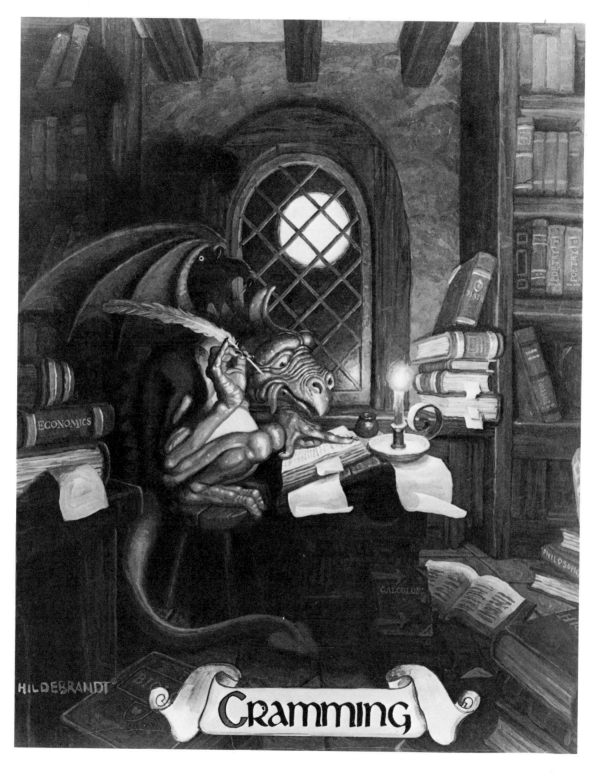

CRAMMING
1977
Camp-us poster series from the Coca-Cola Company

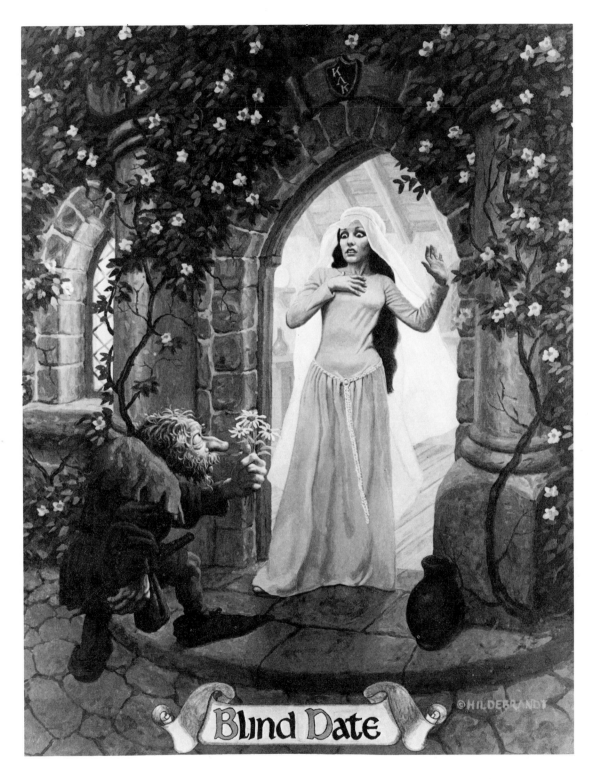

BLIND DATE
1977
Camp-us poster series from the Coca-Cola Company

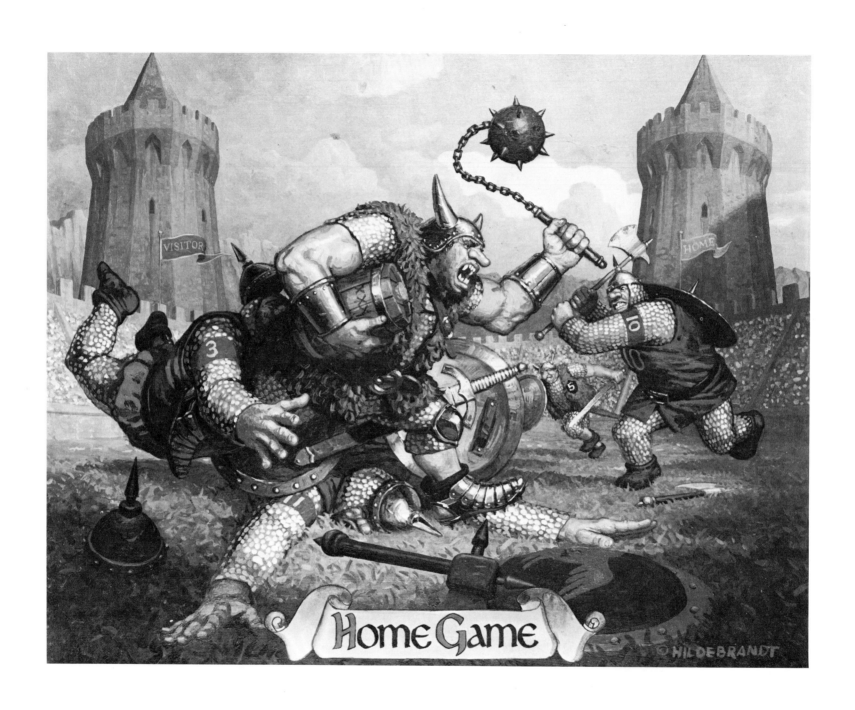

HOME GAME
1977
Camp-us poster series from the Coca-Cola Company

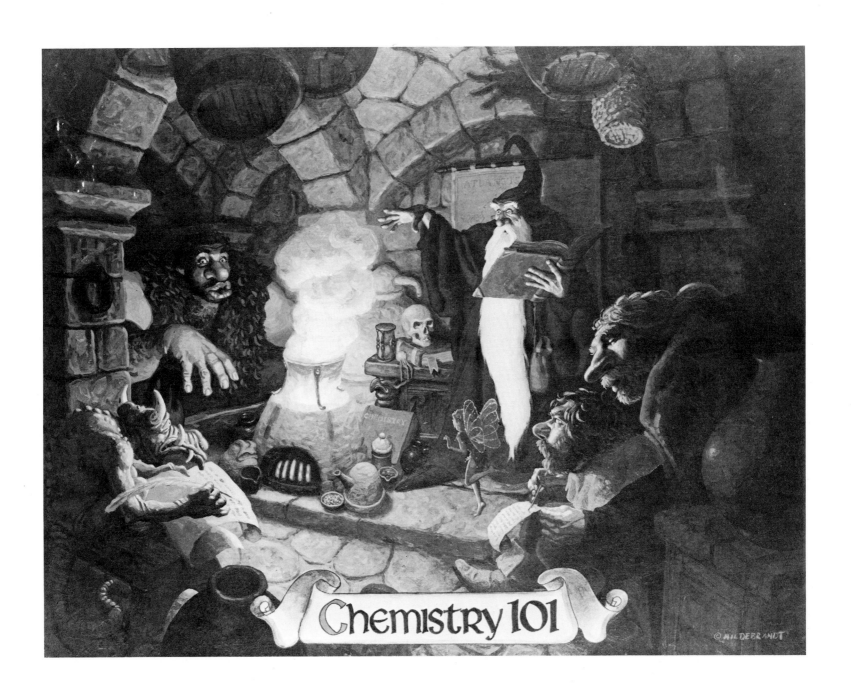

CHEMISTRY 101

1977

Camp-us poster series from the Coca-Cola Company

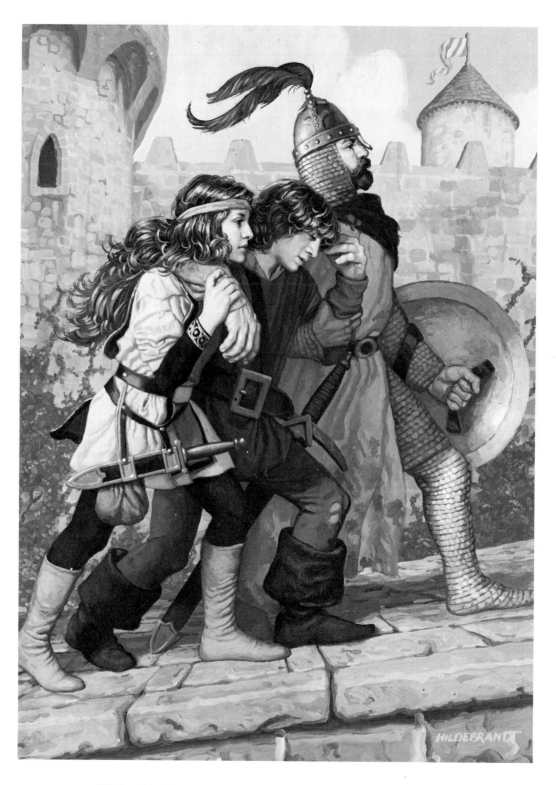

SHIRL ASSISTS MENION TO SAFETY AT HER FATHER'S HOUSE
1977
illustration for The Sword of Shannara—Ballantine Books

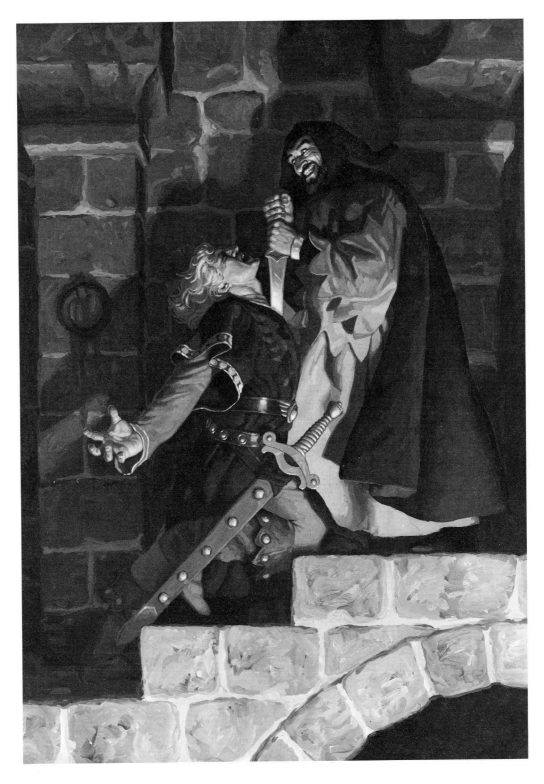

STENMIN STABS PALANCE BUCKHANNAH IN THE DUNGEONS
1977
illustration for The Sword of Shannara—Ballantine Books

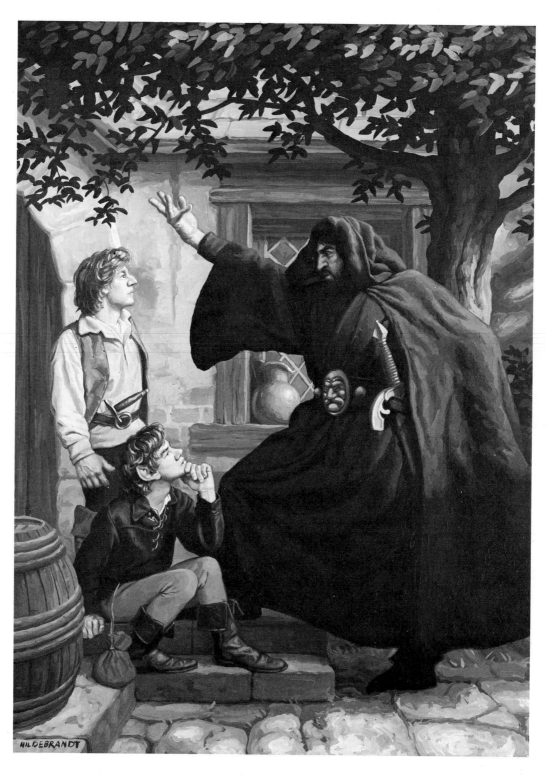

ALLANON RECOUNTS THE HISTORY OF THE RACES AND THE LEGEND OF THE SWORD OF SHANNARA
1977
illustration for The Sword of Shannara *–Ballantine Books*

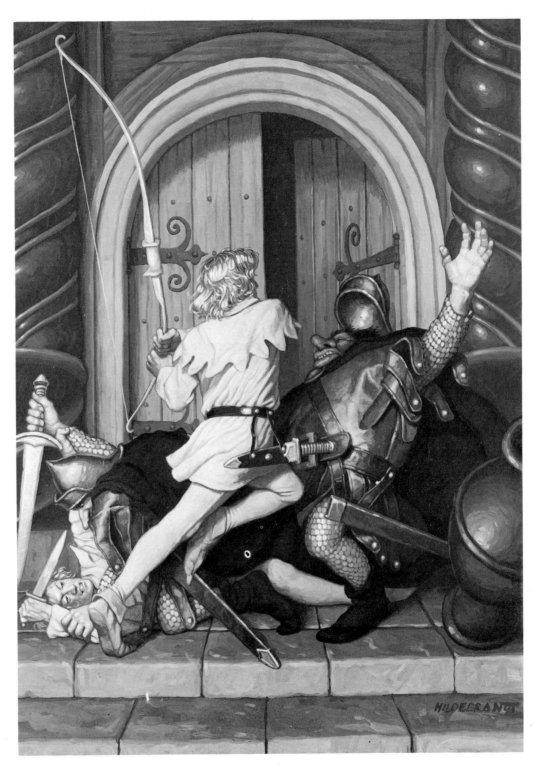

THE ELVEN BROTHERS FIGHT OFF AN ATTACK OF GNOMES IN THE GREAT HALL AT DRUID'S KEEP
1977
illustration for <u>The Sword of Shannara</u>*—Ballantine Books*

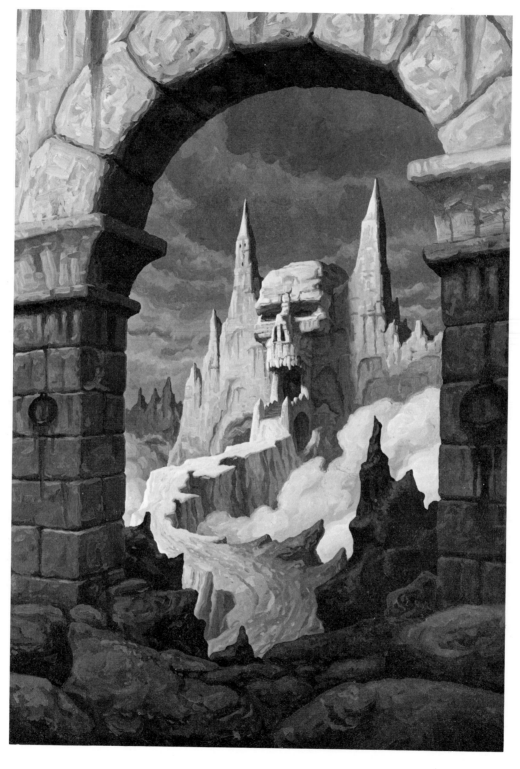

SHEA'S FIRST VIEW OF THE SKULL KINGDOM
1977
illustration for The Sword of Shannara*–Ballantine Books*

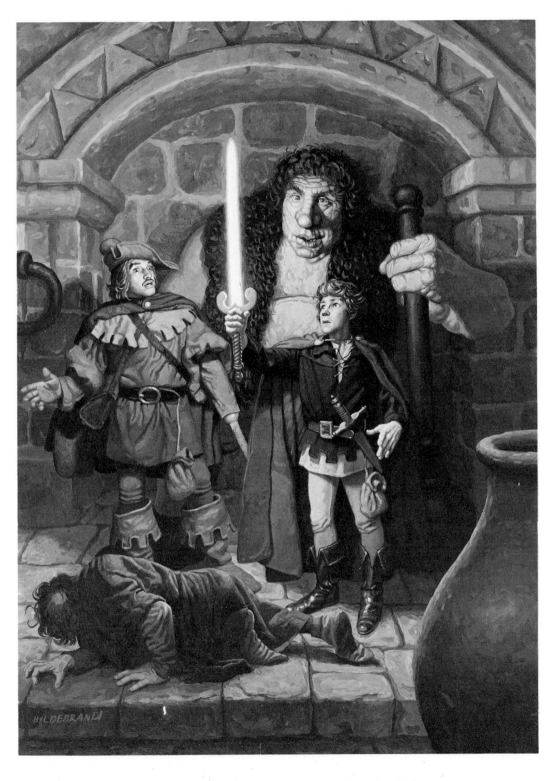

SHEA DISCOVERS THE POWER OF THE SWORD
1977
illustration for The Sword of Shannara—Ballantine Books

BILBO AT RIVENDELL
1976 J. R. R. Tolkien Calendar

THE FELLOWSHIP OF THE RING
1976 J. R. R. Tolkien Calendar (centerfold)
Collection of James Steranko

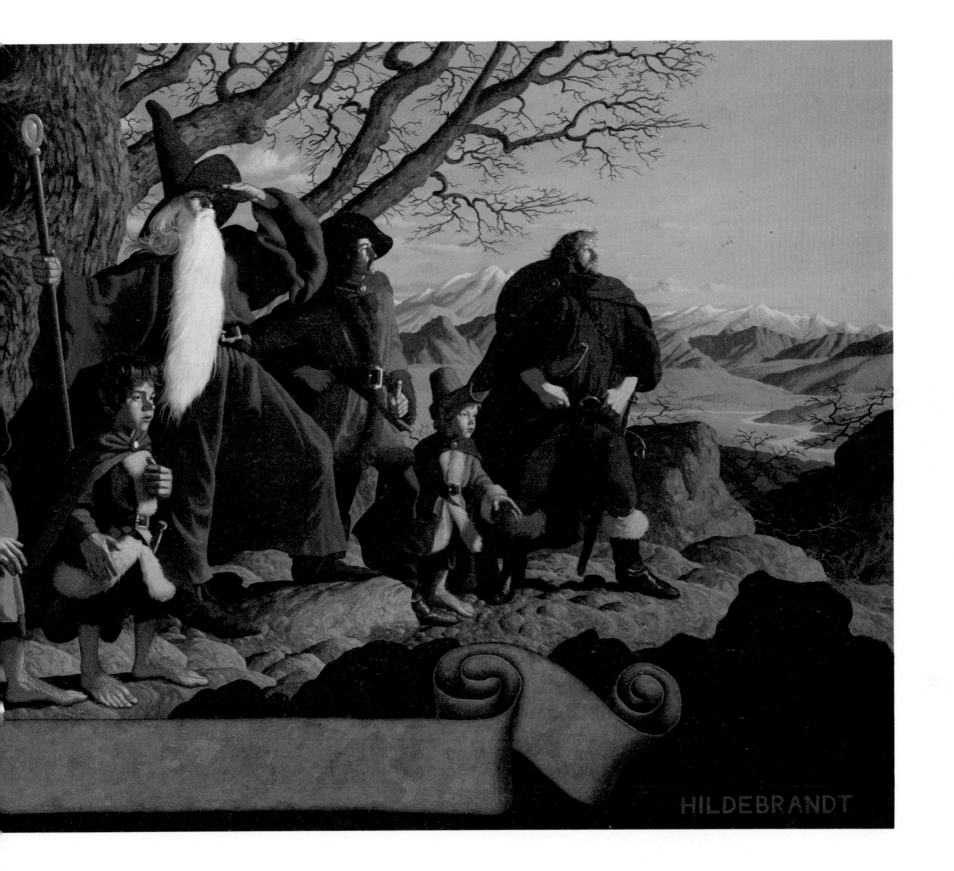

ÉOWYN & THE NAZGÛL
1976 J. R. R. Tolkien Calendar

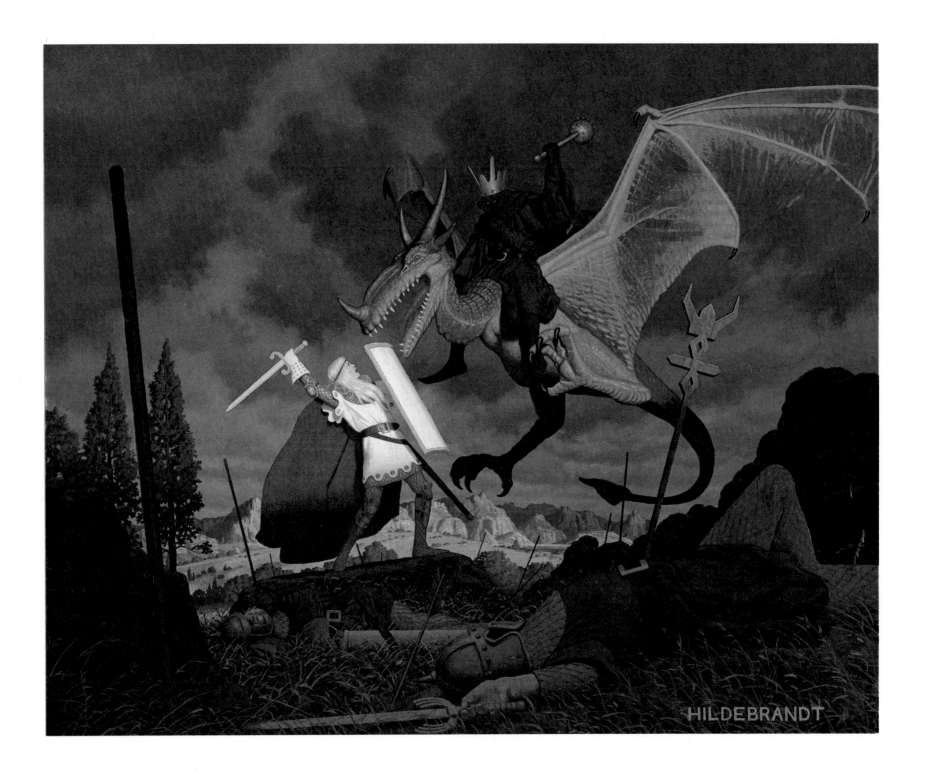

SMAUG
1977 J. R. R. Tolkien Calendar

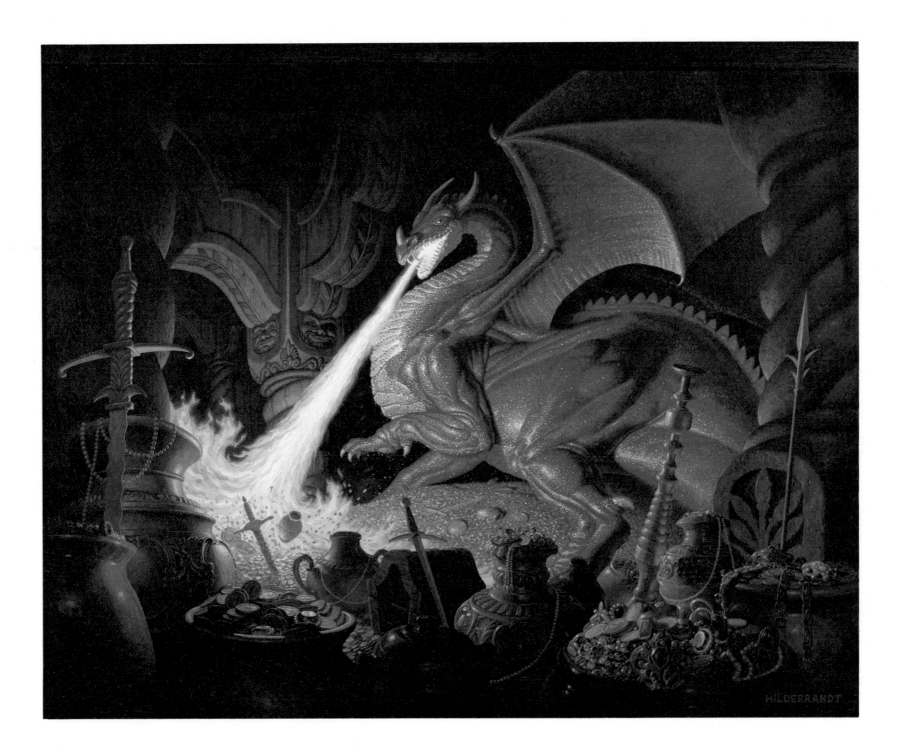

THE BALROG
1977 J. R. R. Tolkien Calendar

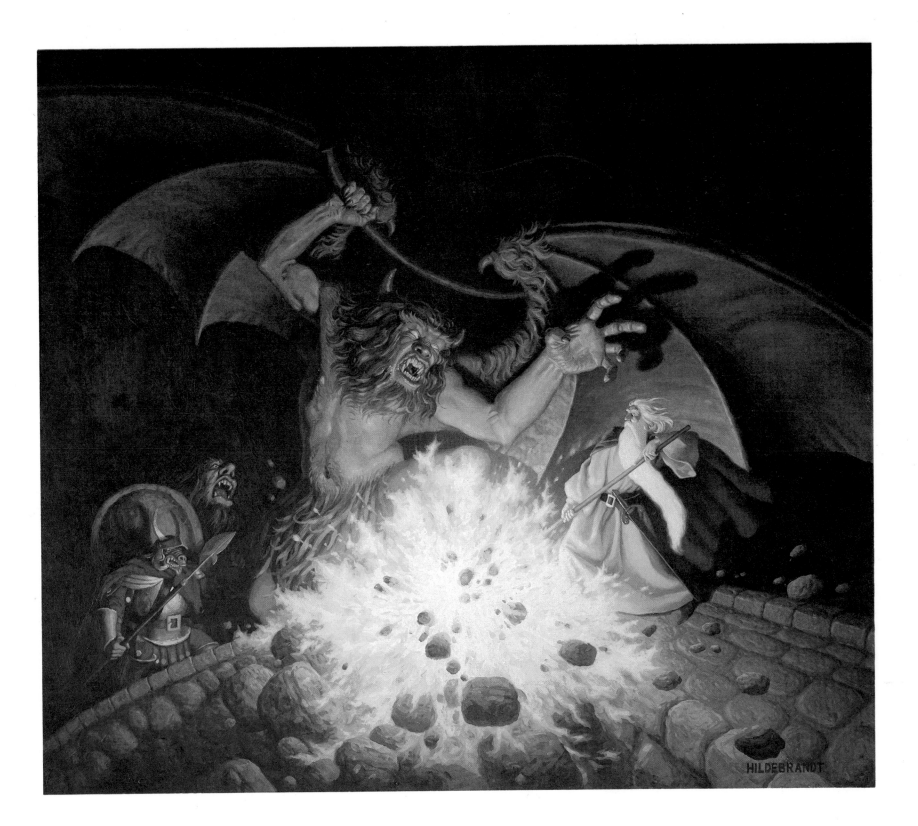

LOTHLÓRIEN
1977 J. R. R. Tolkien Calendar

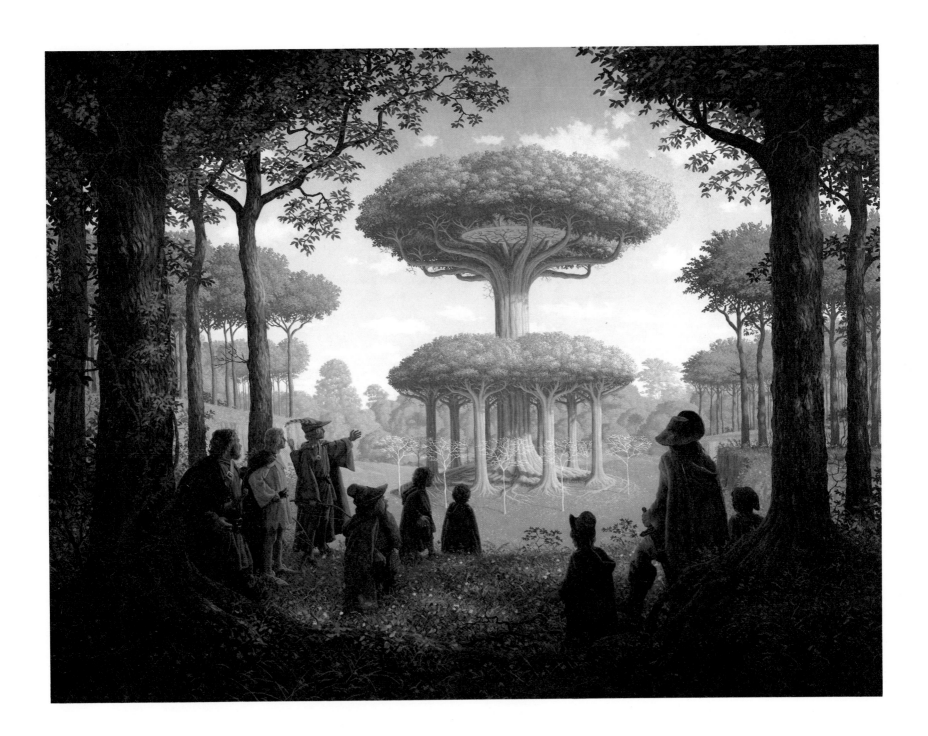

AN UNEXPECTED PARTY
1977 J. R. R. Tolkien Calendar (centerfold)

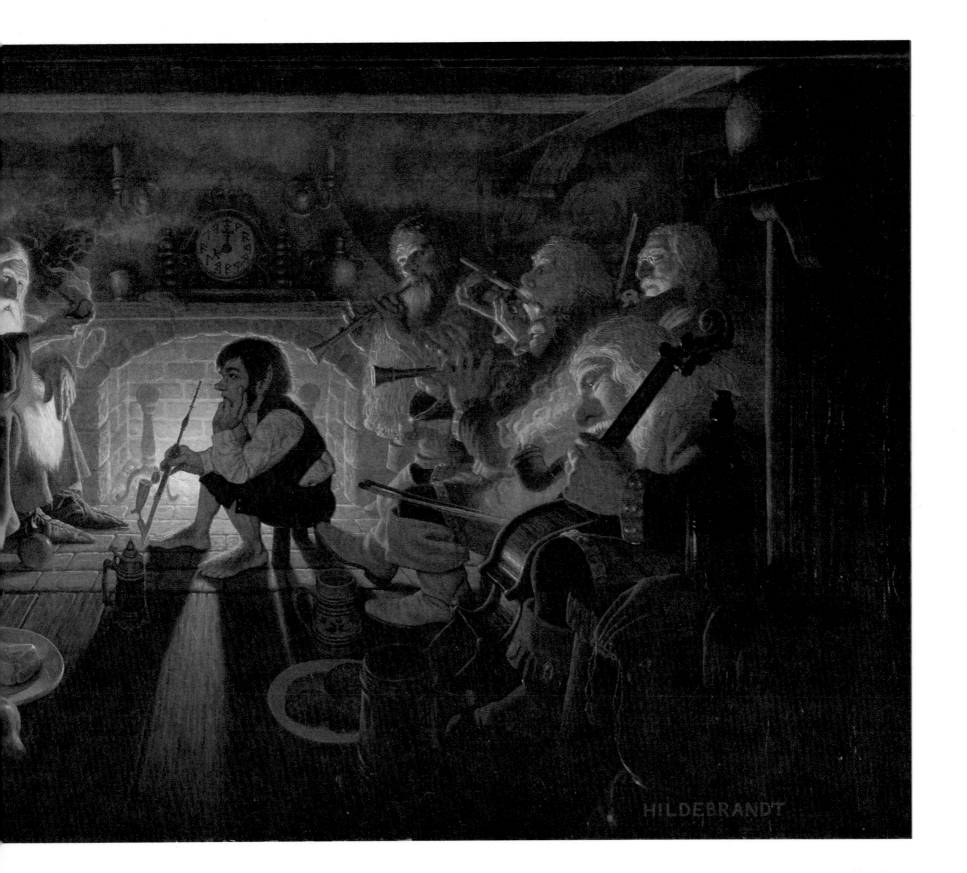

SIEGE OF MINAS TIRITH
1977 J. R. R. Tolkien Calendar

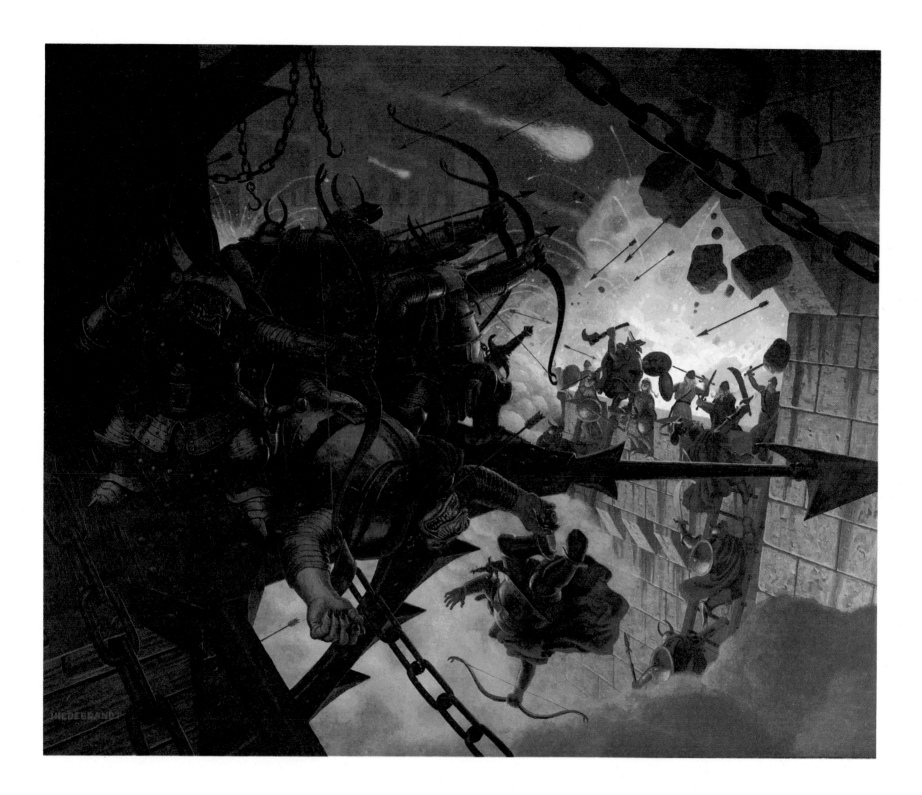

THE HEALING OF ÉOWYN
1977 J. R. R. Tolkien Calendar

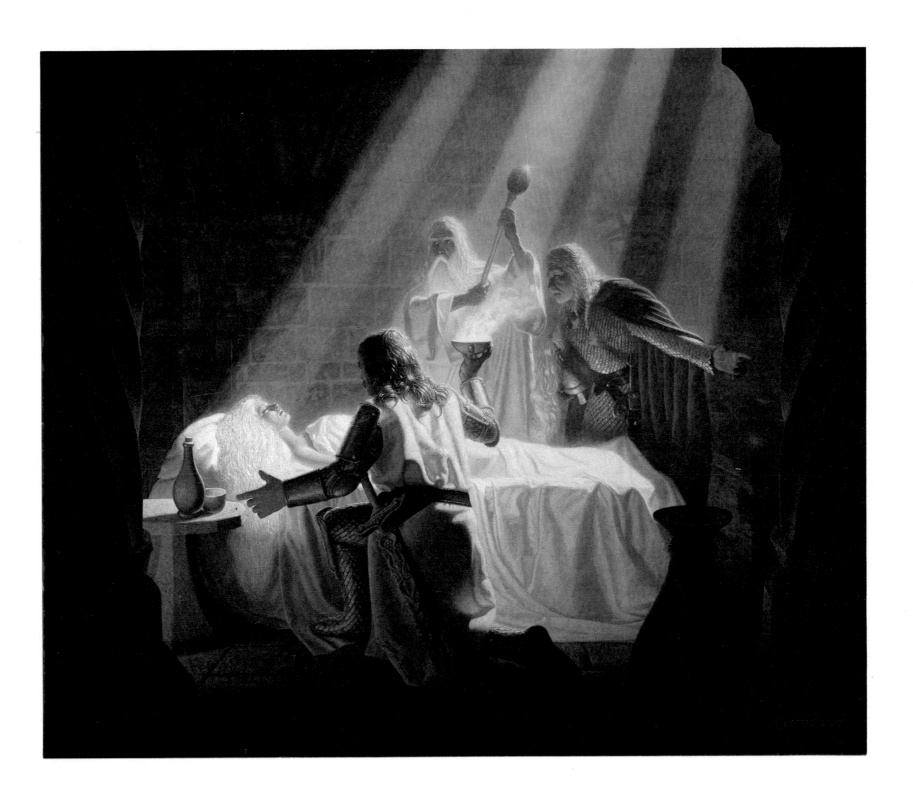

THE WEDDING OF THE KING
1977 J. R. R. Tolkien Calendar

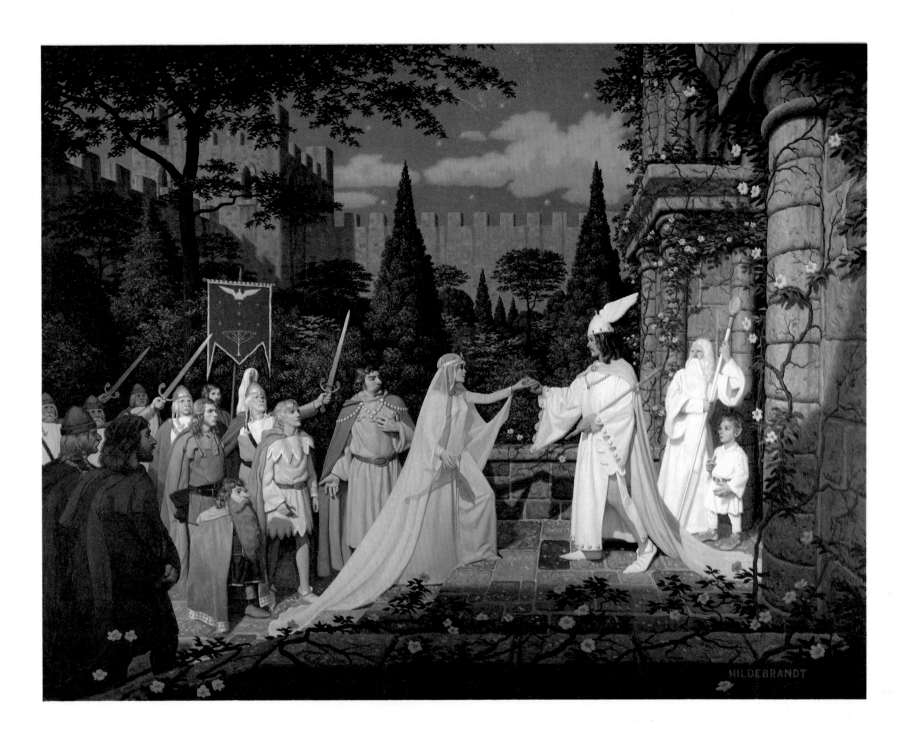

OLD MAN WILLOW
1978 J. R. R. Tolkien Calendar

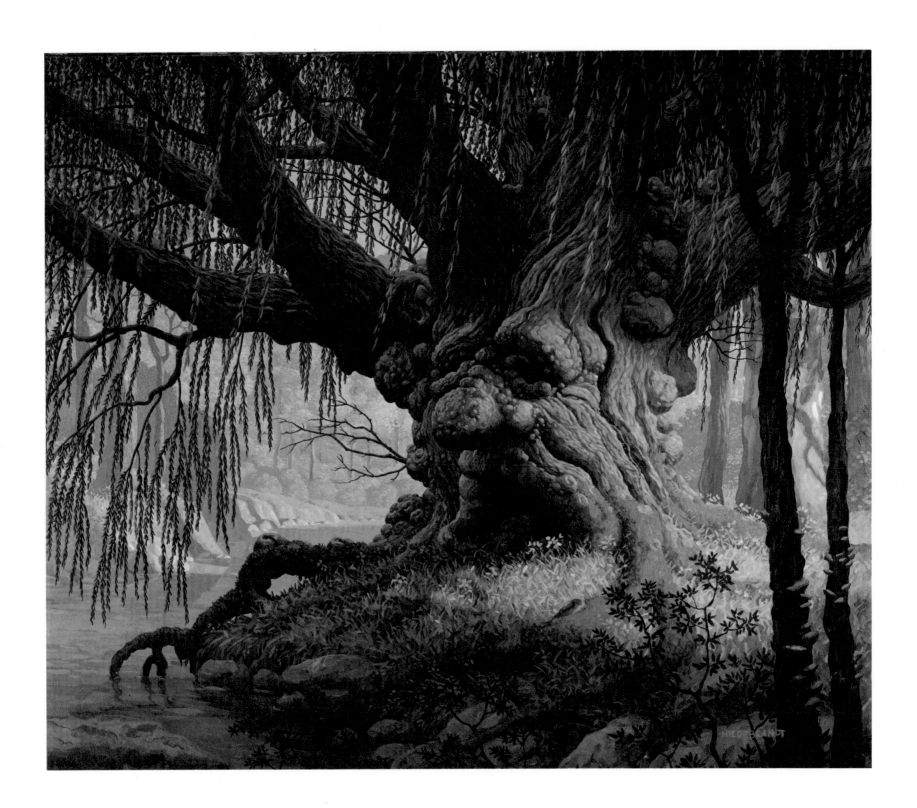

GOLLUM
1978 J. R. R. Tolkien Calendar

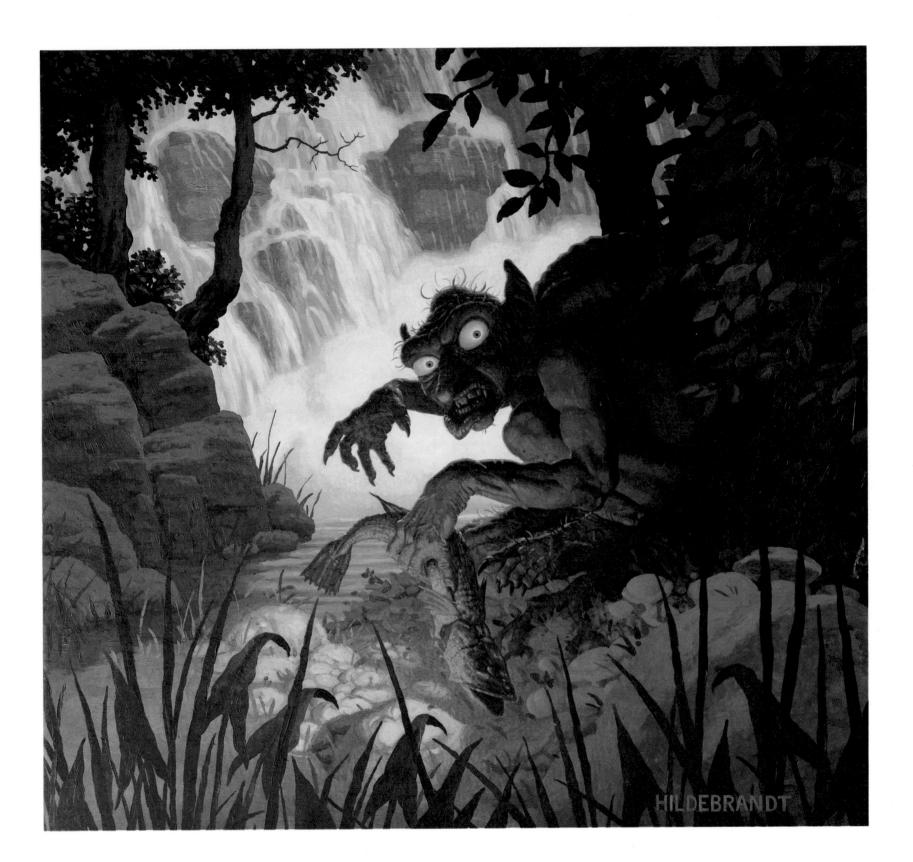

THE RETURN OF GANDALF
1978 J. R. R. Tolkien Calendar

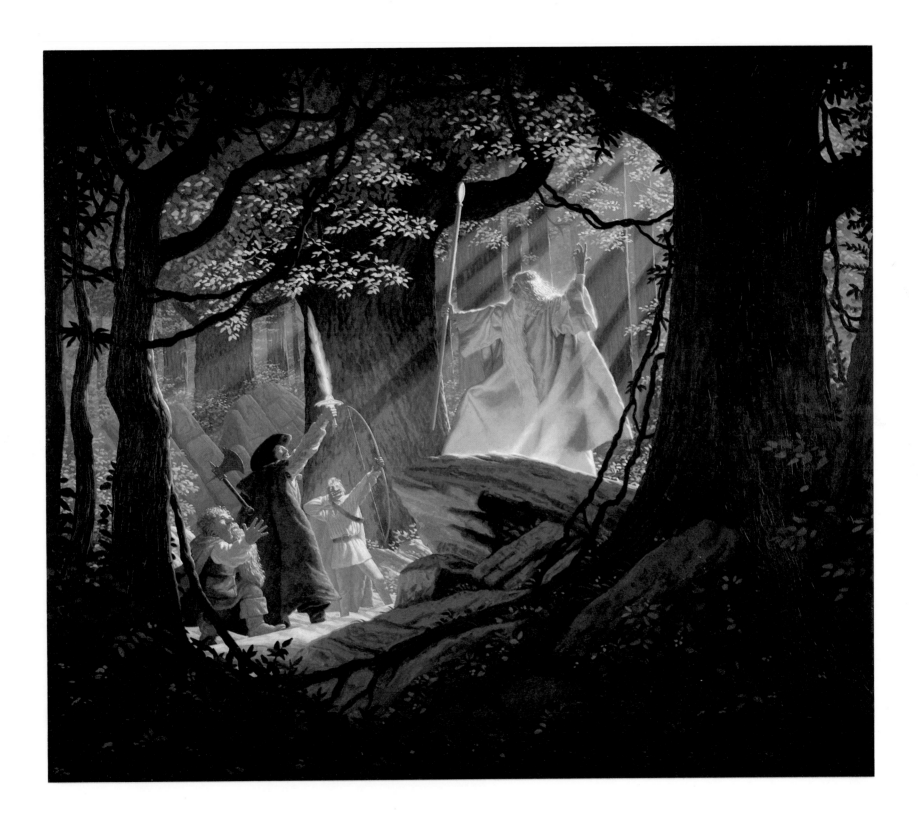

AT THE GREY HAVENS
1978 J. R. R. Tolkien Calendar (centerfold)

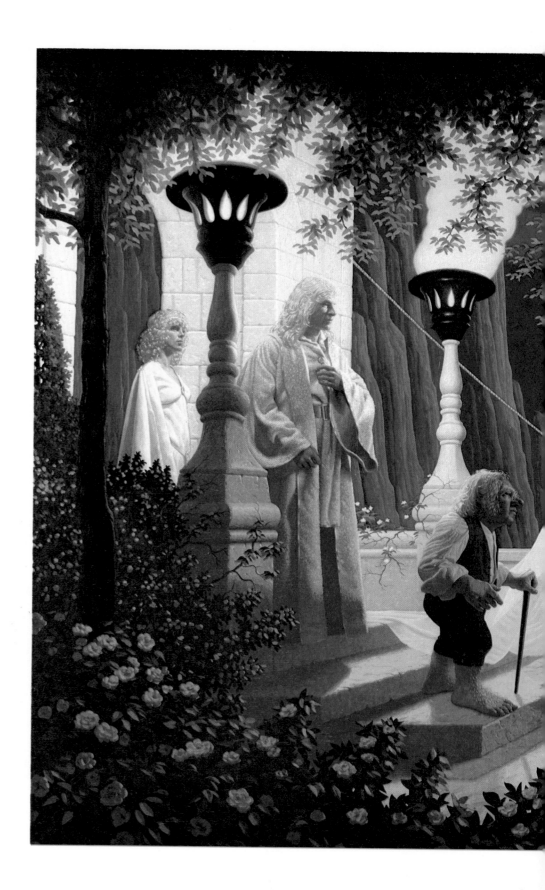

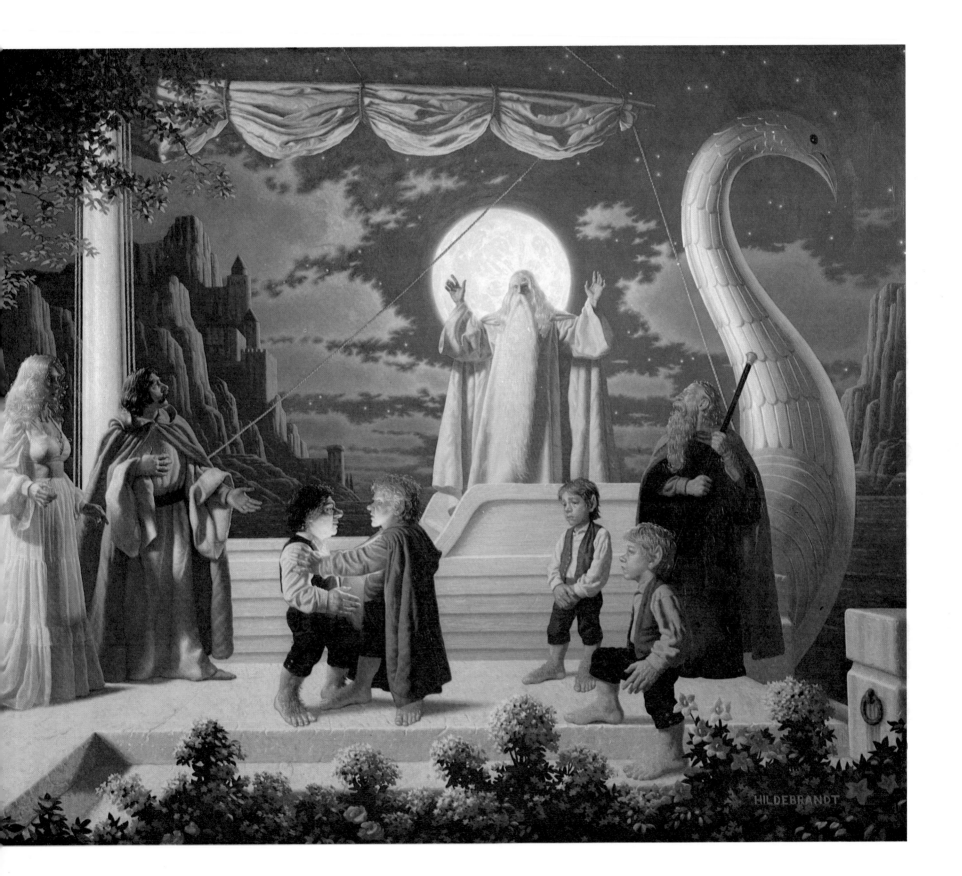

SHELOB
1978 J. R. R. Tolkien Calendar

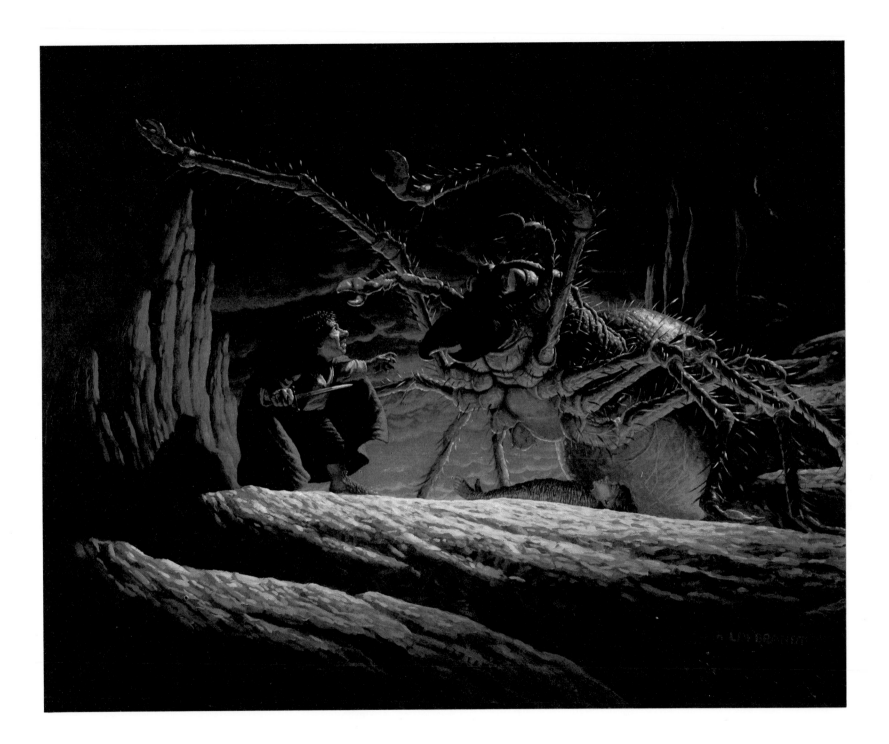

CLIVE: INSIDE THE RECORD BUSINESS
by Clive Davis with James Willwerth
1975
cover illustration for Ballantine Books

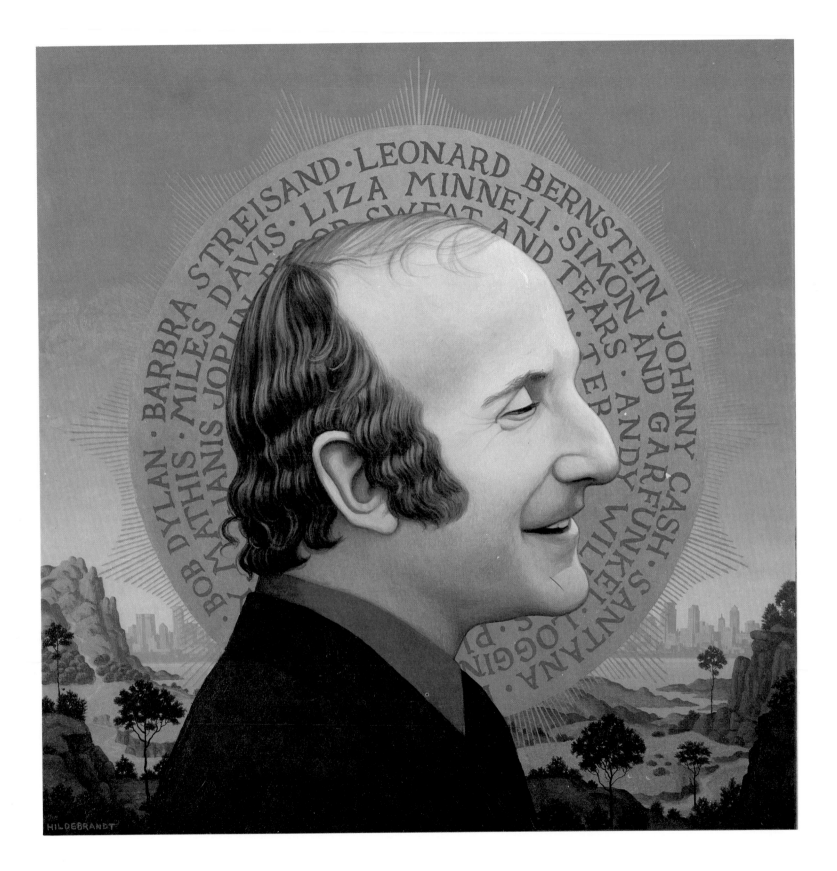

THE EARLY DEL REY VOLUME 2
edited by Lester del Rey
1975
cover illustration for Ballantine Books

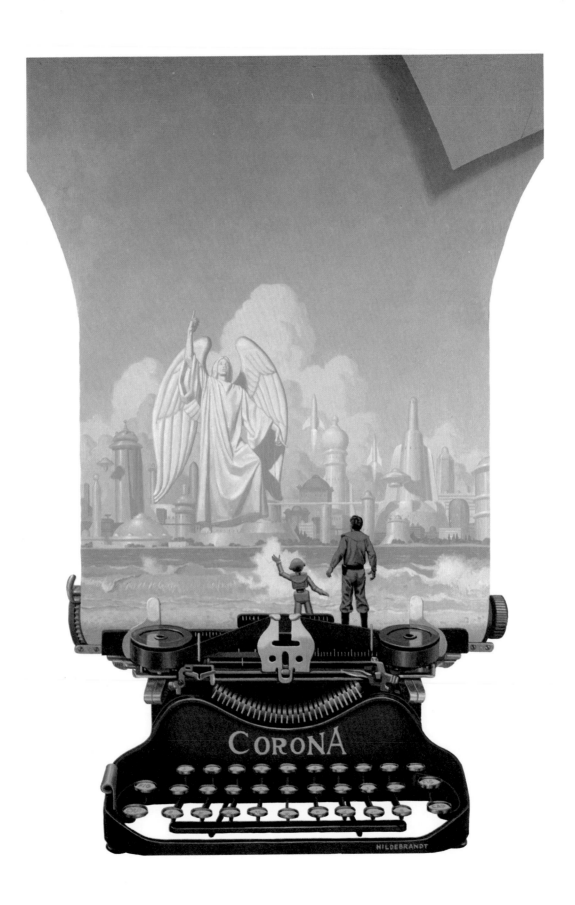

THE BEST OF C. L. MOORE
edited by Lester del Rey
1974
cover illustration for Ballantine Books

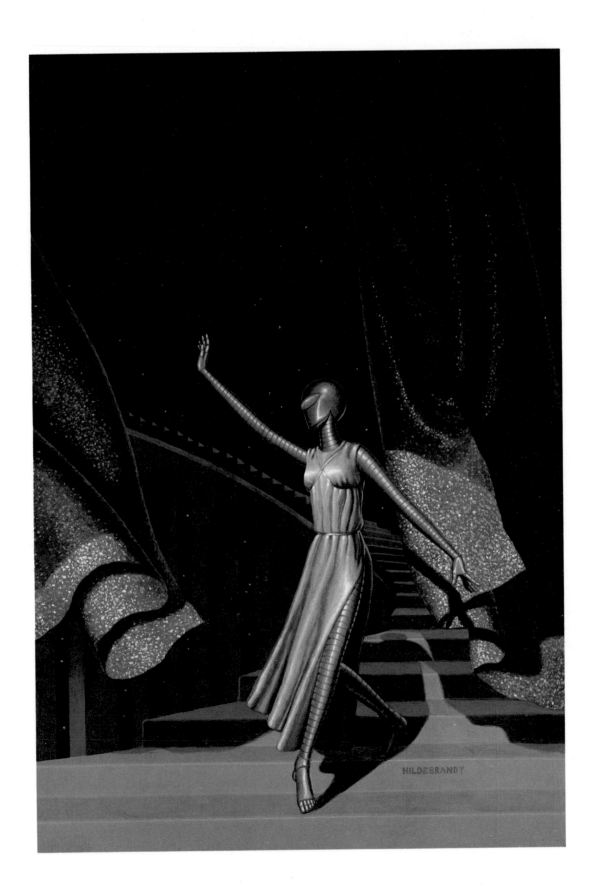

APACHE DEVIL
by Edgar Rice Burroughs
1975
cover illustration for Ballantine Books

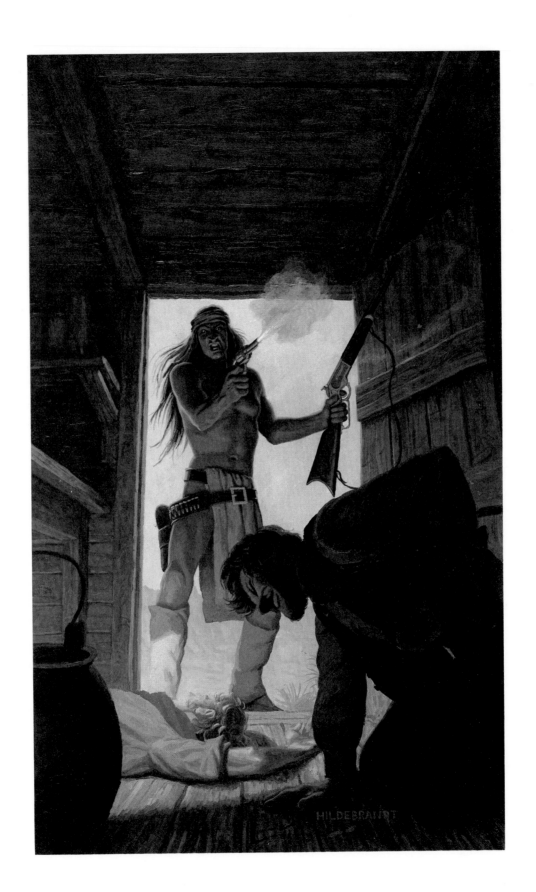

RUN, COME SEE JERUSALEM!
by Richard C. Meredith
1976
cover illustration for Ballantine Books

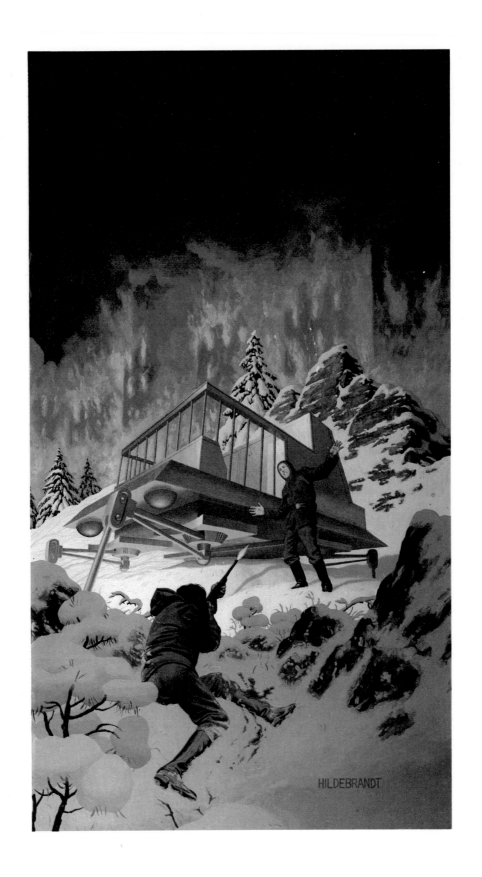

THE SHIP WHO SANG
by Anne McCaffrey
1976
cover illustration for Ballantine Books

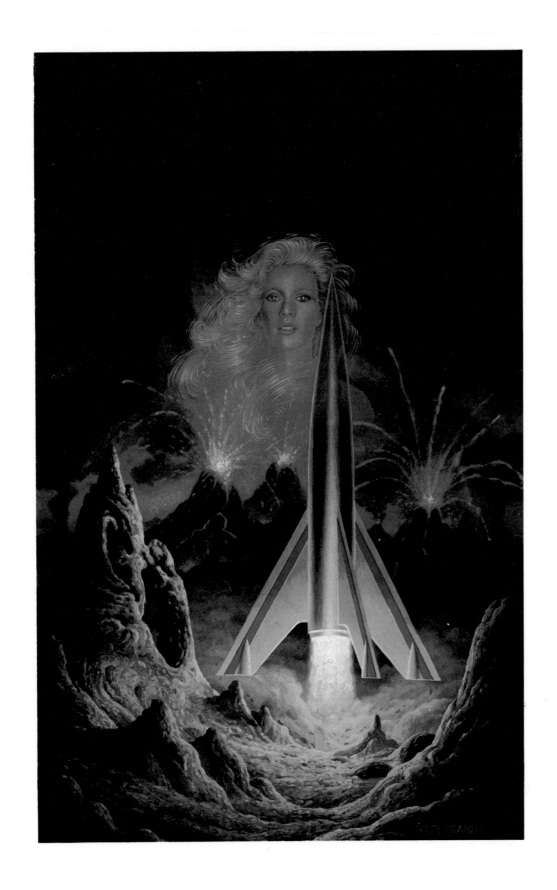

MY NAME IS LEGION
by Roger Zelazny
1976
cover illustration for Ballantine Books

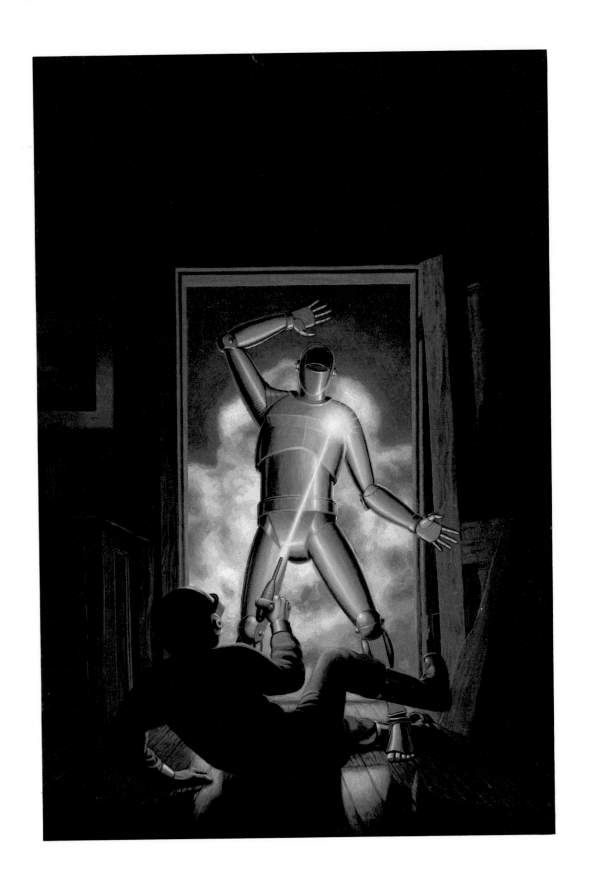

STELLAR #2
edited by Judy-Lynn del Rey
1976
cover illustration for Ballantine Books

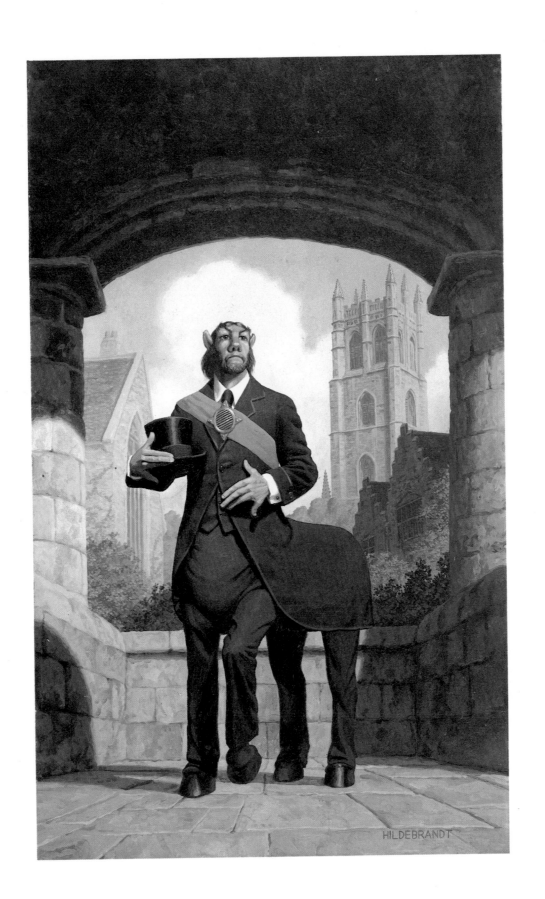

THE EARLY DEL REY VOLUME 1
edited by Lester del Rey
1975
cover illustration for Ballantine Books

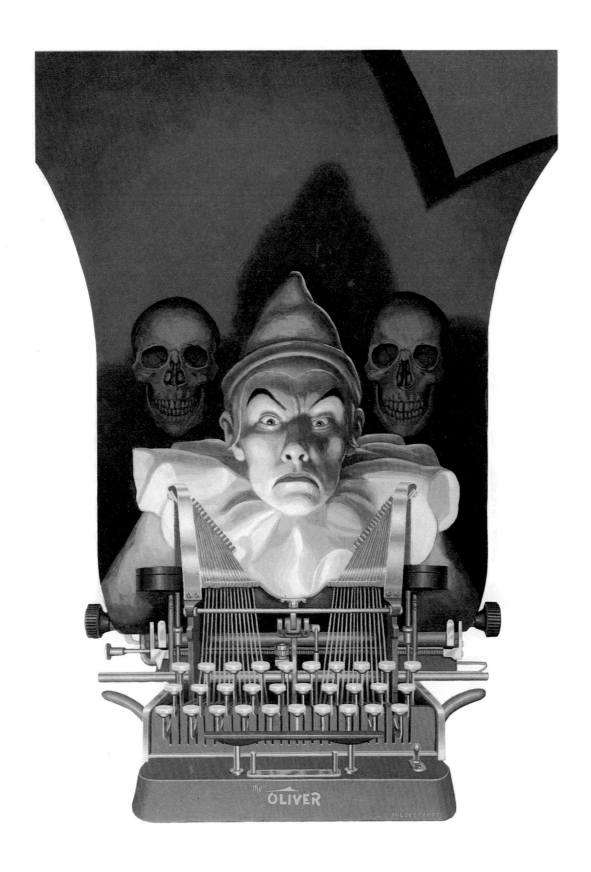

THE SWORD OF SHANNARA
by Terry Brooks
1977
cover illustration for Ballantine Books

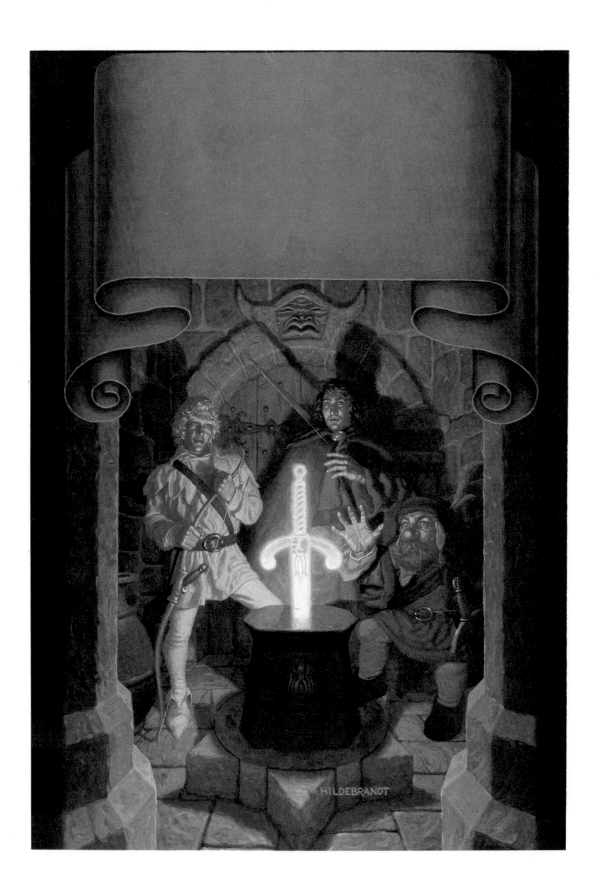

THE SEEKERS OF THE SWORD
1977
centerfold illustration The Sword of Shannara for Ballantine Books

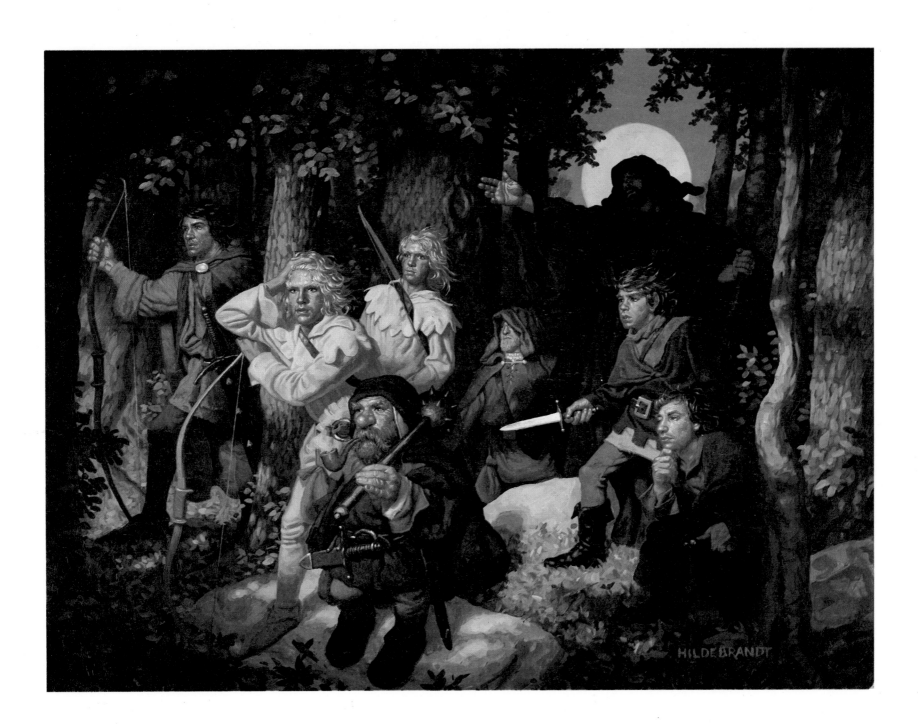

TWINS
1975
collection of the artists

DR. JEKYLL AND MR. HYDE
1974
collection of the artists

UNTITLED
1973
collection of the artists

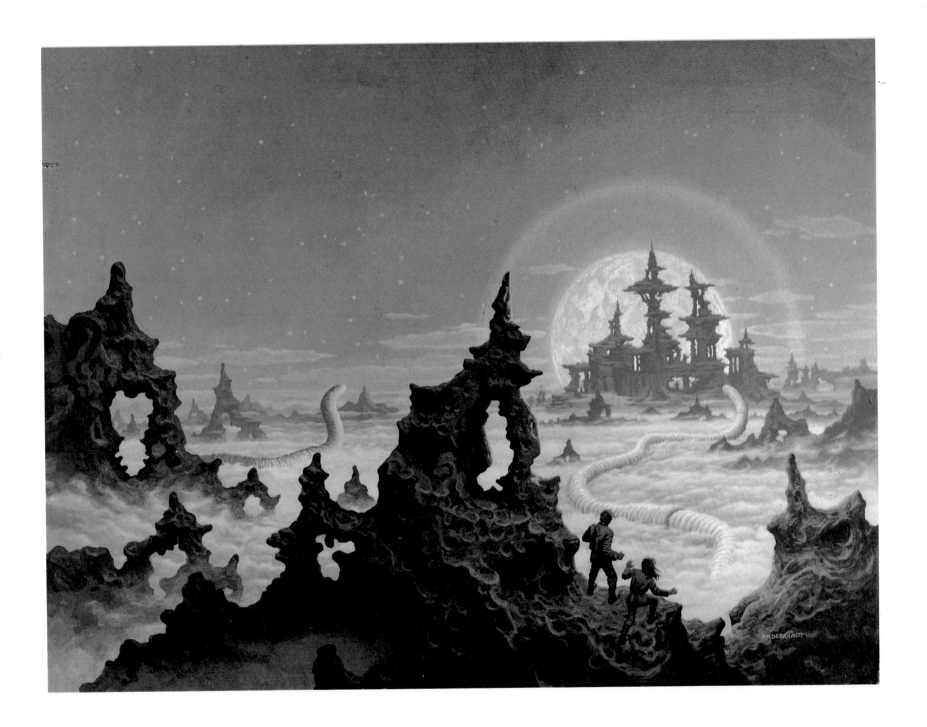

BOB DYLAN
1974
Gregory Hildebrandt
collection of the artist

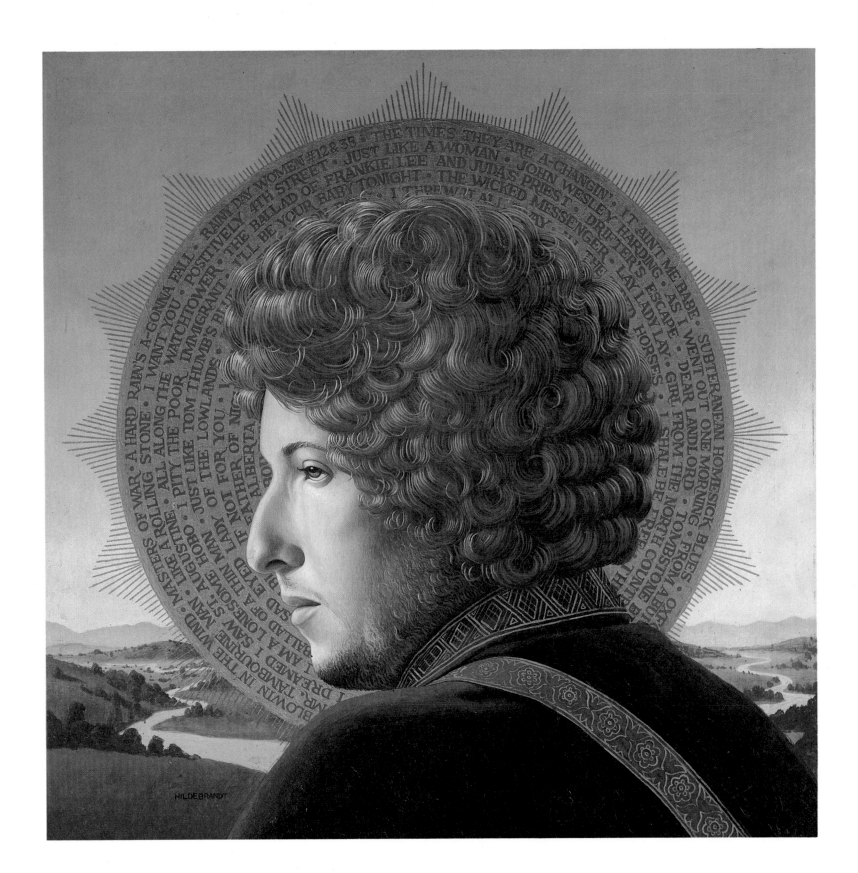

THE TIMES THEY ARE A-CHANGIN' · JUST LIKE A WOMAN · JOHN WESLEY · IT AINT ME BABE · RAINY DAY WOMEN #12 & 35 · POSITIVELY 4TH STREET · THE BALLAD OF FRANKIE LEE AND JUDAS PRIEST · HARDING · SUBTERRANEAN HOMESICK BLUES · WATCHTOWER · I'LL BE YOUR BABY TONIGHT · THE WICKED MESSENGER · DRIFTER'S ESCAPE · WENT OUT ONE MORNING · I WANT YOU · IMMIGRANT · AS I · DEAR LANDLORD · TOMBSTONE · FROM THE · GIRL FROM THE NORTH COUNTRY · ALL ALONG THE POOR · TOM THUMB'S · LAY LADY LAY · I SHALE BE FREE · A HARD RAIN'S A-GONNA FALL · I PITY THE · JUST LIKE · THE · OF THE LOWLANDS · WILD HORSES · MASTERS OF WAR · I WANT YOU · ROLLING STONE · NIGHT · I THREW IT ALL AWAY · ALBERTA · IF · LADY NOT FOR YOU · FATHER · LIKE A HOBO · AUGUSTINE · I DREAMED I SAW · A THIN · SAD EYED · MASTERS A ROLLING · I AM A LONESOME · BALLAD OF · MR. TAMBOURINE · ST. · BLOWIN IN THE WIND · DREAMED I SAW

HILDEBRANDT

MARY
1974
Gregory Hildebrandt
collection of the artist

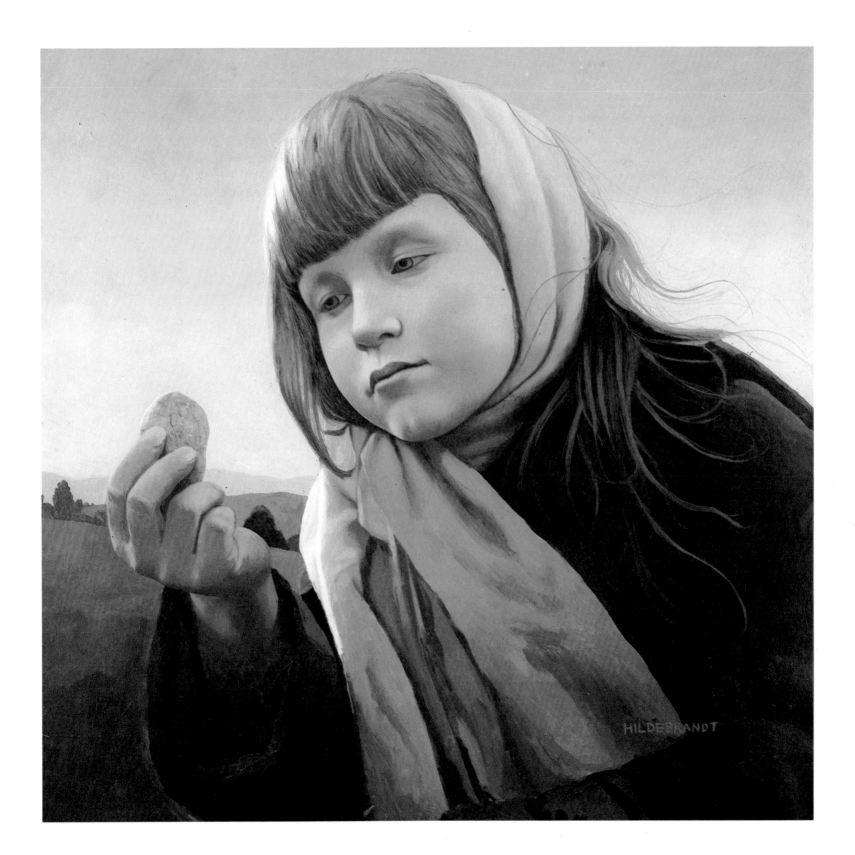

MIKE
1974
Gregory Hildebrandt
collection of the artist

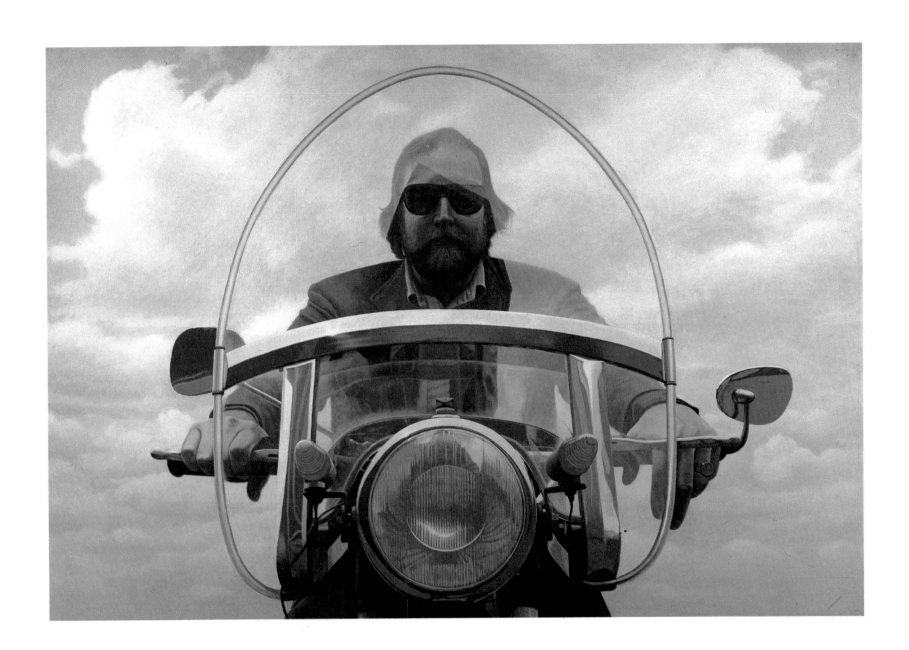

CORKY
1973
Gregory Hildebrandt
collection of the artist

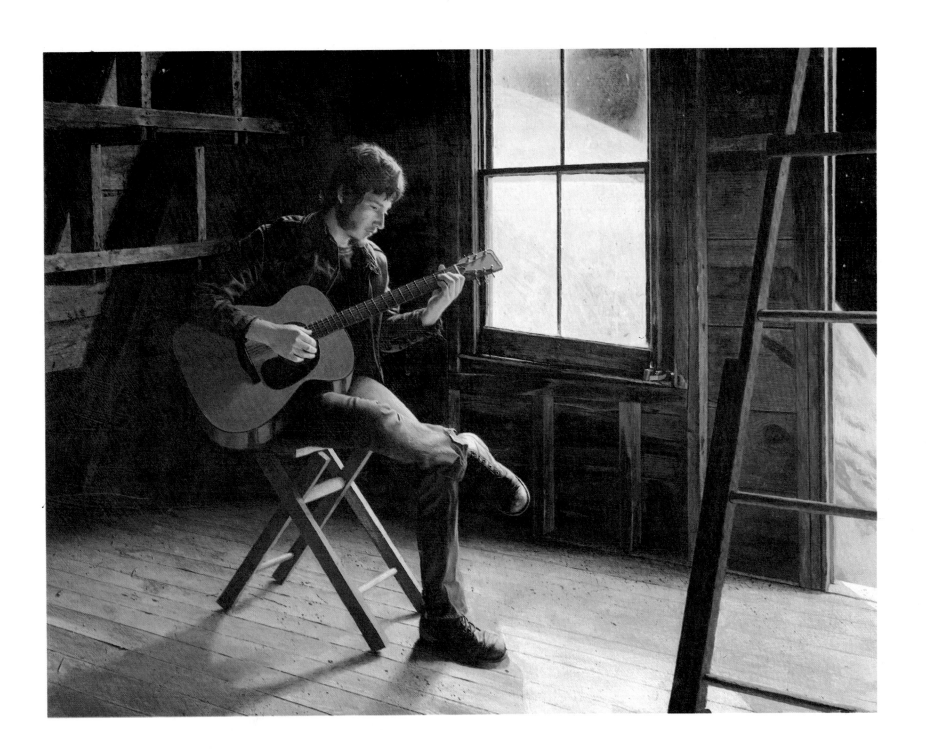

THE MARRIAGE
1972
Gregory Hildebrandt
collection of the artist

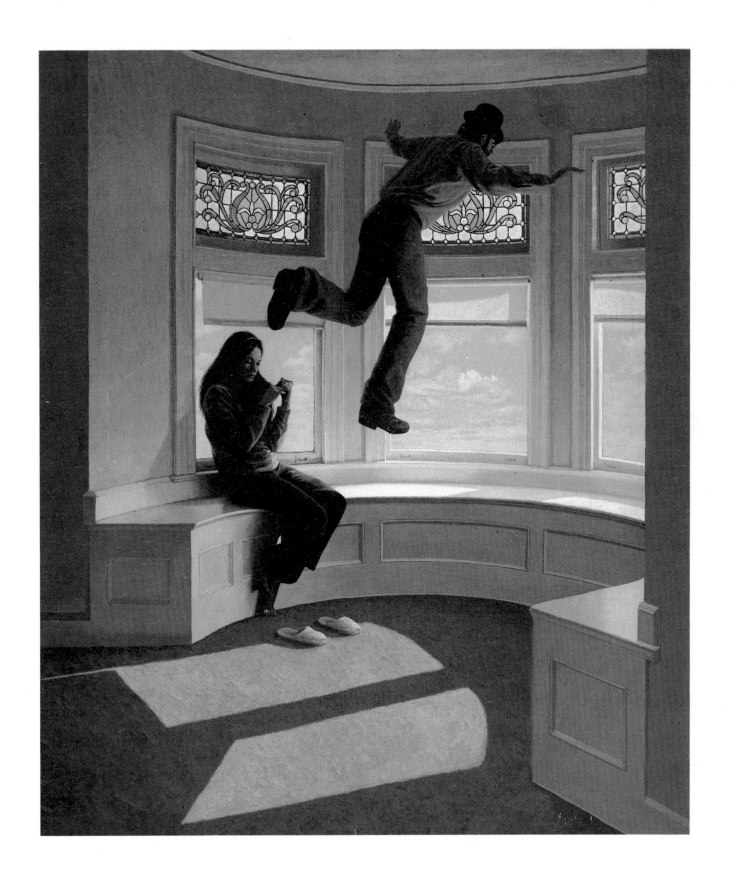

DREAM ONE
1974
Gregory Hildebrandt
collection of the artist

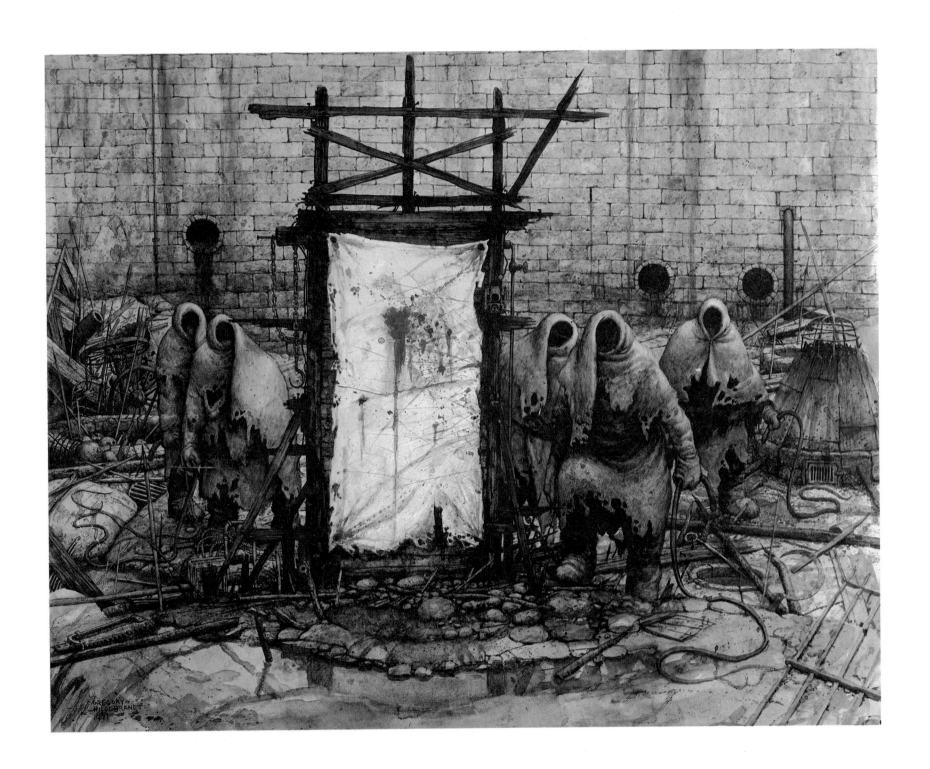

DREAM TWO
1974
Gregory Hildebrandt
collection of the artist

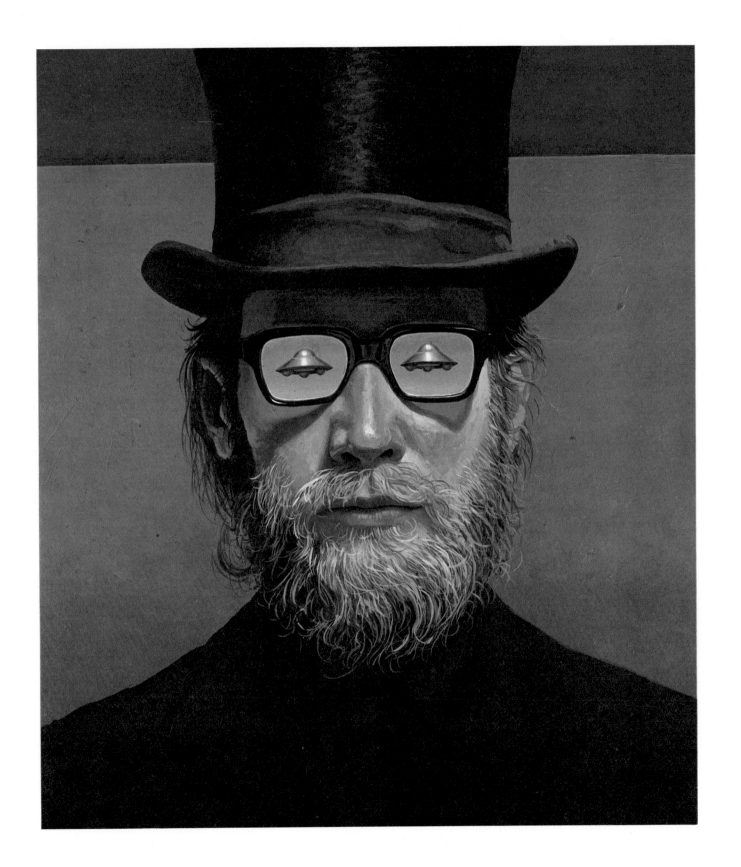

DREAM THREE
1974
Gregory Hildebrandt
collection of the artist

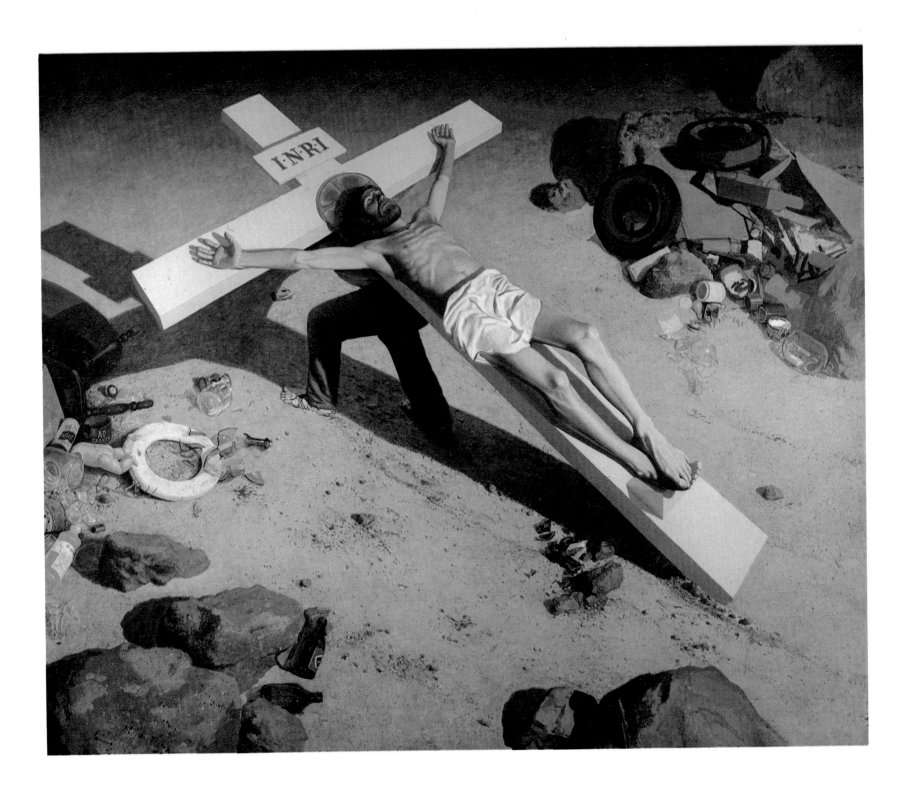

UNTITLED
1974
Timothy Hildebrandt
collection of the artist

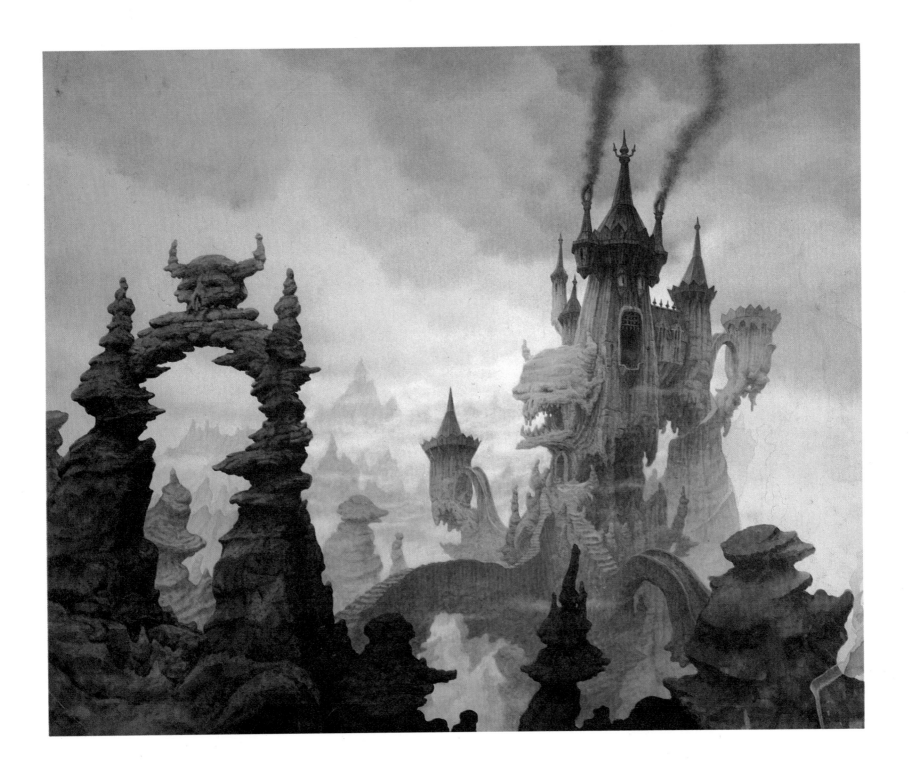

FLAGFACE
1970
Timothy Hildebrandt
collection of the artist

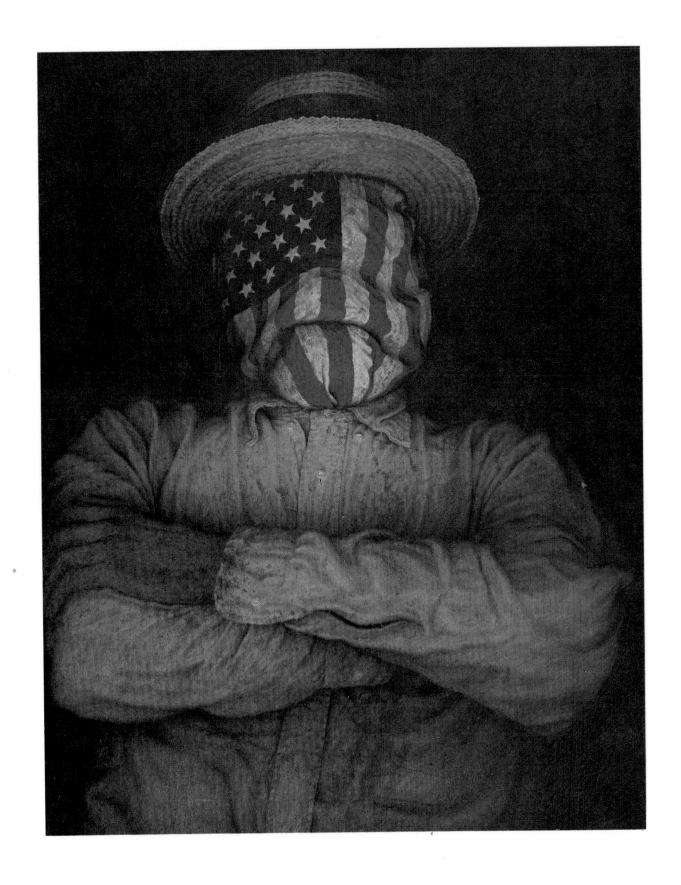

STAR WARS POSTER
1977
Twentieth Century-Fox Film Corporation

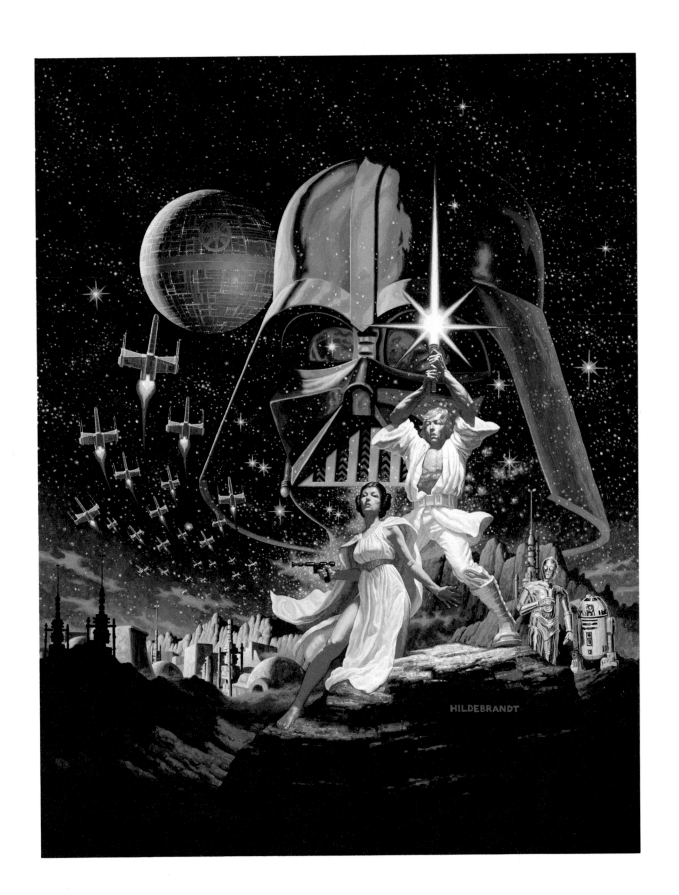